W9-DCC-336

Photographing Works of Art

Techniques for Photographing Your Paintings, Drawings, Sculpture, and Crafts

Photographing Works of Art

By William H. Titus

WATSON—GUPTILL PUBLICATIONS/NEW YORK

I dedicate this book to my
wife, Lois, for her patience,
understanding, and love.

Copyright © 1981 by Watson-Guptill Publications

First published 1981 in the United States and Canada by Watson-Guptill Publications,
a division of Billboard Publications, Inc.,
1515 Broadway, New York, N.Y. 10036

Library of Congress Cataloging in Publication Data
Titus, William H., 1948-
 Photographing works of art.
 Bibliography: p.
 Includes index.
 1. Photography of art. I. Title.
TR657.T57 778.9'97 81-13152
ISBN 0-8230-4009-7 AACR2

Manufactured in U.S.A.

First Printing, 1981

ACKNOWLEDGMENTS

This book would not have been possible without the support and encouragement of innumerable artists, collectors, and friends who have followed its progress from outline to final draft.

To the artists whose works are illustrated, both in a favorable and an unfavorable "light," my thanks for your cooperation and willingness to participate.

To the artists with whom I corresponded regarding the content and format of the book, my thanks for your responses and suggestions.

To those artists with whom I discussed possible inclusion of works in this book, and whose works do not appear here, my thanks for understanding that not all objects present photographic problems.

To Nikon Incorporated, Garden City, New York, and especially Ms. Elaine Schilling of the advertising department, my special thanks for the loan of equipment used in the production of photographs and for allowing me to critically and impartially evaluate its performance.

To Len Totora and the staff of L & L Camera, Huntington, New York, and David Koppele and Charles De Luise of Central Photo, Huntington Station, New York, my thanks for the loan of equipment and materials that were photographed for this book.

To Dorothy Spencer of Watson-Guptill, my very special thanks for encouraging me through every stage of the writing, illustrating, and preparation of this book, and for patience in awaiting its final delivery.

CONTENTS

INTRODUCTION

Artists want and need high-quality black-and-white and color photographs, and color slides and transparencies, for publication, presentation, publicity, and personal records. But unfortunately, while artists are familiar with their own medium, they are often unfamiliar with the craft of photography and with photographic equipment and thus lack the skills necessary to photograph their art.

When initial attempts at photographing objects or paintings are generally unsuccessful, artists may begin a "trial-and-error" period of experimentation until more acceptable photographs are obtained. Or they may ask a friend or relative more familiar with photography for help in producing more acceptable photographs of these works. If this fails, they may be forced to use a professional photographer—at no small expense. "Is there a better way?" they may ask. Yes, there is.

Photographing art is essentially a mechanical process that can be easily learned and used by nonprofessional photographers. Artists working in a limited range of media or a single medium will find that the application of simple procedures and techniques will enable them to photograph their work time and again with easily repeated success. Artists proficient in a wide range of media will find a number of techniques applicable to their needs and will eventually develop a photographic procedure they can transfer from one medium to another.

To successfully photograph works of art, you will need the required photographic equipment and materials, a knowledge of photographic technique, and the ability and methodology to solve problems when they occur. *Photographing Works of Art* is designed to familiarize you with these essentials.

The book is divided into two parts. Part I is concerned with basic information on photography. In this section, currently available equipment and materials—including cameras, lenses, lighting equipment, and film—are examined in detail as they specifically relate to fine-art photography. Also, recommendations are made on the use of specific kinds (though not generally brands) of equipment and answers given to typical questions prompted by reading various chapters.

Part II describes the actual working methods used in photographing art. First, you are presented with a comprehensive and detailed testing procedure that will enable you to critically and objectively evaluate your camera, lens, lighting equipment, films, and photographic ability. You will also be led step-by-step from creating your own test chart to evaluating the results of your tests. Basic information on photographing two- and three-dimensional objects is included within this section as well.

Finally, problems involving equipment or objects being photographed are discussed, such as: photographing works under glass, handling glare, revealing texture, showing paper embossment to advantage, photographing pencil drawings, handling low-contrast subjects, dealing with surface reflections, getting rid of image distortion, and indicating scale. Each problem is discussed and illustrated and procedures are provided where necessary to correct a problem. The primary purpose of the problem section, however, is not so much to offer solutions to specific problems you may encounter, but rather to offer potential solutions to a range of problems you may face in order to build a framework or method of approaching and systematically solving problems of a wider scope than is possible to present within the confines of any book.

The book concludes with two appendices, one containing a list of manufacturers and suppliers of materials for lighting and displaying objects being photographed, and the other listing recommended photographic laboratories.

Photographing Works of Art is both a workbook and reference tool and should be read in its entirety first so you can assimilate the information described before you begin to photograph objects. Remember, the process of photographing art is continuous, and in the process there is room for advance, change, and growth. As new materials are developed, your photographic and artistic methods will change, and as your ability increases, your approaches to problem-solving will expand. By reading and applying the information in this book it is hoped that you will establish your own methods of systematically examining and solving photographic problems. If you can determine what is causing a particular problem, and have the necessary knowledge and equipment to solve it, its ultimate solution will no doubt follow.

Part I.
Basic Information

The process of photographing works of art entails the use of equipment which, at the very least, consists of a camera and lens, a light source (or sources), and film. Within these fundamental categories of equipment, there are many different brands and sizes of equipment that may or may not, by virtue of their design, be suitable for photographing art. There are also several formats and designs of cameras; numerous lenses of different focal lengths; and a wide variety of black-and-white and color films, each with different characteristics, used to produce black-and-white prints, color prints, color slides, and color transparencies. Add to this the many accessories available, and the amount of equipment and materials available to the photographer is greatly expanded.

To the neophyte, novice, or amateur, this array of equipment and materials can seem awesome, and the claims and counter-claims made by manufacturers can be confusing. Therefore, the discussion that follows is designed to enable you to objectively select the equipment best suited to the particular requirements of photographing art and to your own level of skill.

1. THE CAMERA

The camera is a device used to record images of a subject on light-sensitive material called "film." A basic camera (Figure 1) consists of a lens and film connected by a light-proof box. All cameras are essentially refined versions of the basic camera to which other component parts have been added.

A modern camera (Figure 2) contains numerous important components that permit greater control over image composition, focusing, and film exposure than is possible with a basic camera. The extent of control possible varies in accordance with the camera's design.

PARTS OF THE CAMERA

Despite differences in outward appearance, size, and cost, all modern cameras contain nine essential parts: (1) the camera body, (2) the lens, (3) the viewing system, (4) the focusing system, (5) the exposure meter, (6) the diaphragm or iris, (7) the shutter, (8) the film, and (9) the film advance mechanism. Each part contributes to the production of a final photographic image. In the brief summaries that follow, the descriptions of these parts are intended merely to introduce their names and functions. Additional information will be provided throughout the text as required.

THE CAMERA BODY

The camera body houses the other parts of the camera and keeps them accurately aligned with one another. The body can consist of two rigid panels connected by a flexible, accordionlike bellows, as in the case of the view camera (Figure 3), or it can be a rigid, boxlike housing (Figure 4). In either case, the lightproof construction of the body prevents all light from striking and exposing the film except that normally admitted through the lens. The film is located in a compartment at the back of the camera body (Figure 5) to which the photographer has access. The compartment is opened to load and unload film but is lightproof when closed.

THE LENS

The camera lens (Figure 6) receives light that is reflected from the subject and transmits that light to form a reconstructed image of the subject on the film within the camera. A modern camera lens is constructed of several individual pieces of ground and polished glass and a hollow tube within which the pieces of glass are precisely aligned and mounted. Each piece of glass is called a "lens element." The hollow tube is called a "lens barrel." Once assembled, the lens elements and lens barrel perform as a unit and are simply called a "lens."

Commonly available lenses include wide-angle, normal, and telephoto types. A wide-angle lens has a wide view of a scene or subject. A normal lens views the subject in much the same way as it is perceived visually by the photographer. A telephoto lens acts like a telescope, mak-

ing distant objects appear larger and closer to the camera than they actually are. Some cameras will accept different types of lenses in place of one another. These are called "interchangeable lenses."

THE VIEWING SYSTEM

The viewing system consists of a lens and viewfinder through which the photographer views the subject as it will be recorded on the film.

There are two types of viewing systems. The first, as exemplified by the twin-lens reflex camera (Figure 7), uses a viewfinder and separate viewing and picture-taking lenses. The images that are seen in the viewfinder and those that are recorded on the film differ slightly because the two lenses view the subject from slightly different positions on the camera. This effect, called *parallax error*, limits the photographer's ability to view the subject exactly as it will be photographed.

The second system, as exemplified by the single-lens reflex camera (Figure 8), uses a viewfinder and one lens that serves alternately to both view and photograph the subject. Because one lens is used for both purposes, the system does not exhibit parallax error. In fact, the image seen in the viewfinder *is* the image recorded on the film.

THE FOCUSING SYSTEM

The focusing system (Figure 9) permits the photographer to maintain a sharp, clear image of the subject in the viewfinder and on the film by moving the viewing and picture-taking lenses toward or away from the film. When the image is focused in the viewfinder, it will also be focused on the film when it is exposed. Without a focusing system, changes in distance between the subject and the camera could result in fuzzy, out of focus images.

THE EXPOSURE METER

The exposure meter is a photoelectric device that measures light intensity in relation to the sensitivity of a particular film to light. If too much or too little light

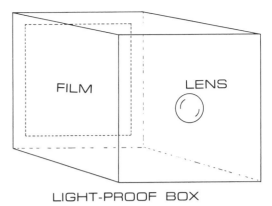

LIGHT-PROOF BOX

1. A basic camera consists of a lens and film connected by a lightproof box. Only light admitted through the lens strikes and exposes the film.

2. A modern camera consists of: (1) a camera body; (2) lens; (3)viewing system; (4) focusing system; (5) diaphragm of iris; (6) shutter; (7) film; and (8) film advance mechanism. It also contains an exposure meter, which is not illustrated here because its position varies with the camera model.

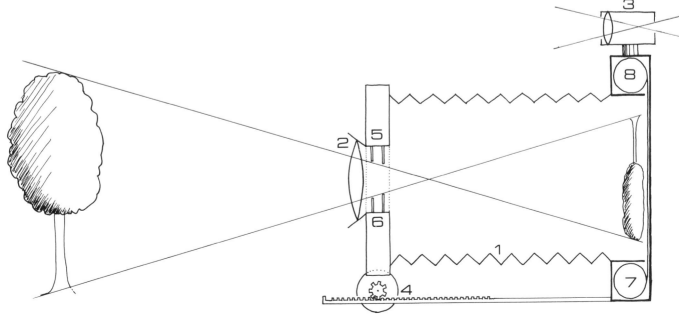

3. *A view camera consists of a lens panel at the front of the camera and a film holder/ground glass focusing panel at the rear of the camera, connected by a flexible bellows.*

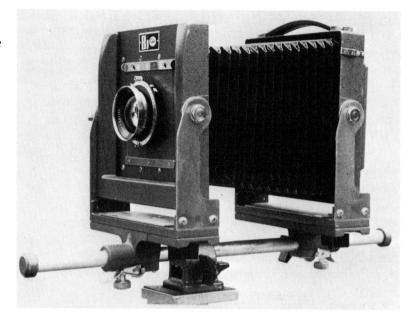

4. *A single-lens reflex (SLR) camera holds the lens and film in fixed positions by means of a rigid, boxlike housing.*

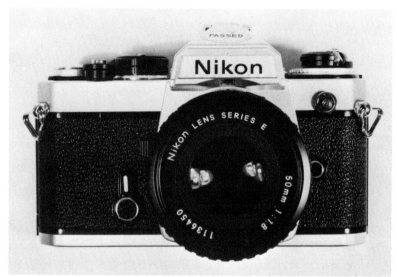

5. *The film compartment of a single-lens reflex camera is opened to load and unload film. It is closed during film exposure.*

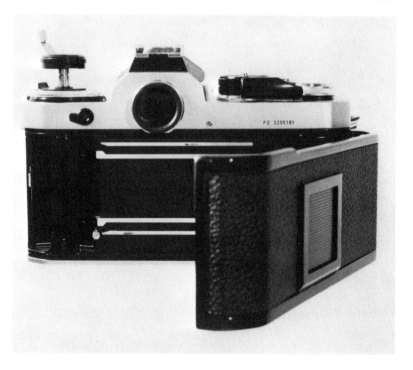

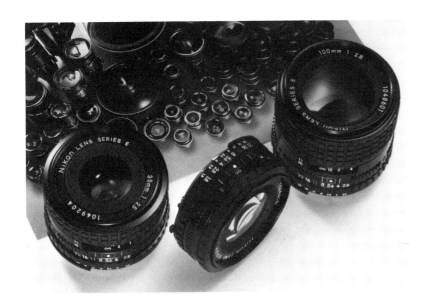

6. *Typical 35mm camera lenses.*

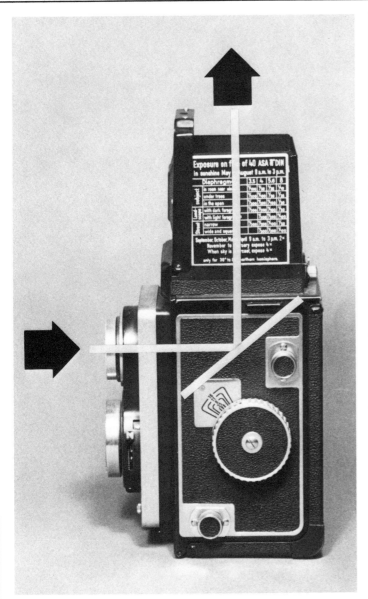

7. *The viewing system of a twin-lens reflex camera is mounted above the picture-taking lens in the camera body* (left). *The image of the subject is reflected upward by a mirror within the viewing system and is viewed from above on a focusing screen* (above).

8. *The picture-taking lens of the single-lens reflex camera also serves as the lens for the viewing system prior to and following film exposure. A mirror within the camera* (right) *reflects the image formed by the lens upward to a viewing screen. When the shutter is released, the mirror swings upward out of the light path so that the film will be struck by the light when the shutter opens. With the camera's pentaprism removed* (below and bottom), *the image can be seen as it is formed on the viewing screen. The pentaprism rectifies the image as seen through the viewfinder.*

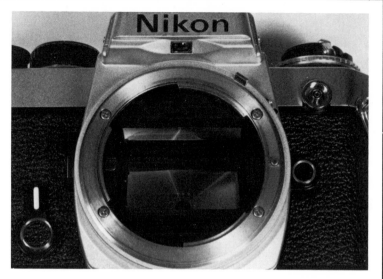

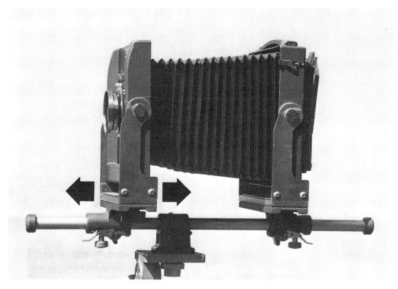

9. *The lens (here the example shows a view camera) is moved toward or away from the film to focus the image sharply in the viewfinder and on the film.*

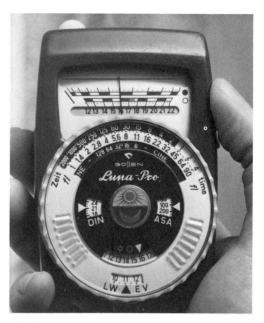

10. *Most in-camera exposure meter systems are inaccessible. However, the hand-held reflectance exposure meter shown here contains the same basic components and operates much like the exposure meter housed within the camera.*

strikes and exposes the film, the resulting image will be an inaccurate rendition of the subject. Exposure meter measurements are used to compute the proper combination of lens aperture and shutter speed that will result in an accurate photographic image.

There are two basic types of exposure meters: the reflectance meter and incident meter. A *reflectance* meter measures the amount of light actually reflected by the subject. Reflectance meters are built into most hand-held or small format cameras and are also available as hand-held instruments (Figure 10). An *incident* meter, available only as a hand-held unit, measures the amount of light falling on the subject. Both types of meters can be used to accurately measure light intensity.

THE DIAPHRAGM
The diaphragm or iris (Figure 11) forms a variable opening by means of a series of overlapping metal blades located within the camera's picture-taking lens. The photographer can adjust the diameter of the opening to control the *quantity* of light admitted into the camera. Increasing the diameter of the aperture admits more light into the camera and is called "opening up" the lens. Decreasing the diameter of the aperture admits less light and is called "stopping down" the lens.

THE SHUTTER
The shutter is a movable shield that controls the *duration* of film exposure. It is normally closed to protect the film from being exposed by light entering through the lens aperture.

When a picture is taken, the shutter opens, remains open for a predetermined amount of time, then closes quickly. The duration of film exposure is limited to the amount of time (the shutter speed) selected by the photographer. A powerful spring insures the instantaneous opening and closing of the shutter.

11. *The overlapping metal leaves of the diaphragm or iris form a variable opening or aperture that determines the quantity of light admitted through the lens. In combination with the shutter, the aperture is used to control film exposure.*

12. *The shutter controls the duration of film exposure. Here the separate, overlapping metal leaves of the leaf shutter are shown in the process of opening. The diaphragm, located immediately behind the shutter in this view camera lens, is also visible.*

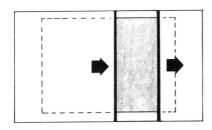

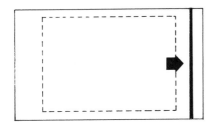

13. *The focal-plane shutter consists of two flexible but opaque curtains that are drawn, one following the other, from one side of the camera's interior to the other. The light transmitted by the lens exposes the film through a gap separating the curtains as they sweep across the focal plane. The width of the gap is determined by the shutter speed selected.*

There are two basic types of shutters: leaf shutters and focal-plane shutters. A *leaf* shutter (Figure 12) is usually located between the elements of the lens and consists of overlapping metal blades similar to those used for the aperture. The shutter opening is formed when the leaves pivot away from the center of the lens simultaneously.

A *focal-plane* shutter (Figure 13) is located near the focal plane of the camera. It consists of two flexible but opaque curtains that are drawn, one following the other, from one side of the camera's interior to the other. The light transmitted by the lens exposes the film through a gap separating the two curtains as they sweep across the focal plane. The width of the gap is determined by the shutter speed selected.

THE FILM
Film consists of a light-sensitive emulsion of silver salts, called "halides," and gelatin bonded to a tough, flexible transparent base (Figure 14). Light focused on the film by the lens alters the silver particles so that later chemical processing will produce a negative or positive image of the subject, depending on the type of film used. Light and dark tones in the subject are reversed in negative films but remain the same in positive slide or transparency films.

Films vary in their sensitivity to light. Films sensitive to light have high ASA (American Standards Association) numbers and are called "fast" or "high-speed" films. Those less sensitive to light have low ASA numbers and are called "slow" films.

THE FILM-ADVANCE MECHANISM
The film-advance mechanism or film transport (Figure 15) moves exposed film onto a spindle where it can receive no further exposure. In the process, unexposed film is moved into place behind the shutter and, through a system of gears, the shutter spring is wound or "cocked." As a result, the camera is fully prepared for the next exposure.

TYPES OF CAMERAS
Cameras are distinguished from one another by the size of the film they use, the size of the images they produce, and the viewing system they employ. There are many different sizes of film and film images, but there are only five major types of viewing systems used in modern cameras. These are: single-lens reflex, direct vision ground-glass, coupled rangefinder, twin-lens reflex, and direct vision. The following descriptions of the viewing systems and the cameras that use them will acquaint you with commonly available equipment. The systems are organized in the order of their usefulness to nonprofessional photographers of art.

THE SINGLE-LENS REFLEX CAMERA
The single-lens reflex (SLR) camera (Figure 16) uses the same lens for viewing and photographing the subject and is equipped with a focal-plane shutter and an exposure meter. A movable mirror reflects the image of the subject

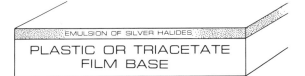

EMULSION OF SILVER HALIDES

PLASTIC OR TRIACETATE
FILM BASE

14. *Film, both black-and-white and color, consists of a light-sensitive emulsion of silver salts, called "halides," bonded to a transparent support.*

15. *In roll-film cameras the film advance mechanism moves exposed film from behind the shutter to a take-up spool while moving unexposed film into position for exposure behind the shutter. The film advance lever is rotated (top left). The film is advanced one frame for each full rotation of the lever, and exposed film is wound onto the take-up spool (left).*

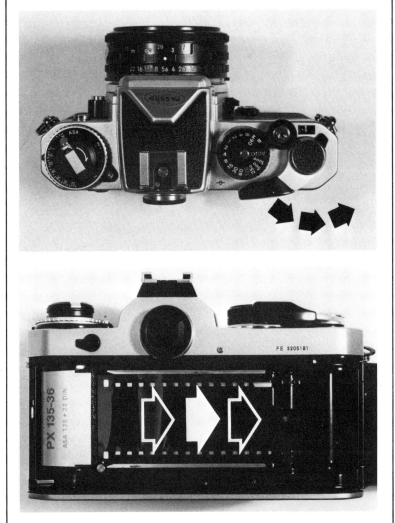

16. *Single-lens reflex (SLR) camera.*

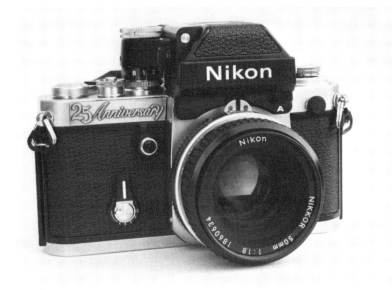

that is transmitted by the lens to a translucent screen for viewing and focusing. The mirror image reflected on the screen is reversed from left to right. A five-sided glass prism (pentaprism) attached to the camera body directly above the viewing and focusing screen rectifies the image so that it appears the same as the original. The pentaprism also transmits the corrected image through an eyepiece at the rear of the camera.

The movable mirror is linked mechanically to the focal-plane shutter. At the instant the shutter spring is released, the mirror moves up out of the path of incoming light. It thus covers the focusing screen from beneath and prevents unwanted light that is entering through the eyepiece from striking the film. When the film exposure is completed, the mirror returns to its original position.

The exposure meter is located within the camera, where it measures only the light reflected by the subject and admitted by the lens. Meters of this type are called "behind-the-lens" meters. Exposure-control settings, as adjusted in accordance with the meter reading, appear in the viewfinder. In automatic cameras, the exposure meter controls the shutter speed, the aperture, or both to insure a "properly" exposed negative or slide. However, most automatic models provide for adjustment of the exposure controls by the photographer when the automatic controls are switched off or defeated.

On most SLRs, interchangeable lenses can be substituted for the lens normally supplied with the camera. When the lens is changed, the resulting changes in the field of view are immediately apparent in the viewfinder.

Camera manufacturers and independent photo equipment manufacturers offer innumerable accessories for both the camera and its lenses.

ADVANTAGES. The most important advantage of the single-lens reflex camera over other types of cameras is its accurate viewing system: the images viewed and photographed are virtually the same. In other words, there is no parallax error. This enables the photographer to center the image on the film accurately and permits quick recognition of distortion of the image or of focus problems before the film is exposed, while it can still be corrected.

The camera's compact size, built-in exposure meter, interchangeable lenses, and many accessories make the SLR a versatile and useful recording instrument.

DISADVANTAGES. The SLR is a complex instrument. While breakdowns are not inevitable, when they do occur repairs are more expensive than for simpler non-SLR cameras.

Although focusing the SLR in dim light is not usually a problem when photographing works of art, it can be difficult depending on the type of viewing/focusing screen installed in the viewing system and the maximum (largest) aperture available on the camera's lens.

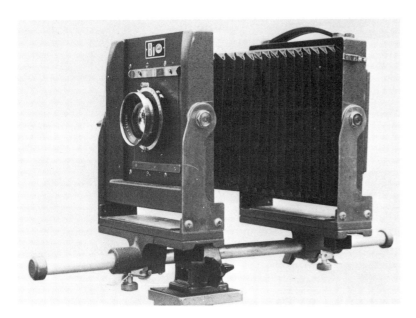

17. Direct vision ground-glass view camera.

FORMATS. Single-lens reflex cameras are available in 110, 35mm, and 120/220 roll film, as well as in Polaroid SX-70 format.

THE DIRECT VISION GROUND-GLASS VIEW CAMERA
The view camera (Figure 17) is an exceptionally versatile instrument. Like the SLR, it uses one lens to view and photograph the subject. The shutter is located within the lens, along with the diaphragm. Both the shutter and the diaphragm are opened to compose and focus the image that is transmitted by the lens onto the ground-glass focusing screen at the back of the camera. To prevent the image from being diluted by ambient light, a black cloth is draped over the photographer and the ground-glass screen while adjustments are made in composition and focus.

Focus is achieved by moving the lens or focusing screen panels toward or away from one another. This is possible because the panels are connected by a flexible bellows. The bellows of the view camera body also permits the lens and ground glass to be positioned so that many types of camera-caused distortion can be controlled or eliminated.

Once the subject has been composed and focused, the lens and ground-glass panels are locked in place, the shutter is closed, and the lens diaphragm is adjusted to the desired aperture. The ground glass is replaced by a film holder containing one unexposed sheet of film on each of its two sides. An opaque slide protects the film from exposure until the holder is safely within the camera's lightproof interior. The protective slide is then removed so that the film can be exposed.

ADVANTAGES. The view camera's chief advantages are: versatility and flexibility unsurpassed by any fixed-body camera; high-quality, large-format images; availability of a wide variety of different types of sheet film,

some of which are unavailable in other formats; ability to control or eliminate particular types of camera-caused distortion; and acceptance of interchangeable lenses.

DISADVANTAGES. View cameras are primarily used by professional photographers experienced in their use, so unless you fully utilize this camera's flexibility, the view camera is not a worthwhile investment. First of all, despite its versatility, the view camera lacks many features most modern cameras have—a built-in exposure meter, for example, so you will require a hand-held exposure meter to calculate shutter and aperture settings. Then, a large number of incidental accessories are required to operate the camera under a variety of circumstances. A strong, sturdy tripod is another essential—the camera is unmanageable and unwieldy without one.

Another disadvantage is that the image viewed on the focusing screen is inverted, making it difficult for some people to view. Also, the sheet film it uses must be loaded and unloaded in a darkroom. Then, the price of the film for each exposure is relatively higher than smaller format film. And the sheet film used in a view camera is not processed by film manufacturers. It must be processed by independent photo laboratories or in your own darkroom.

FORMATS. View cameras are available in the following sheet film sizes: 2¼×3¼″ (57×83mm), 4×5″ (100×125mm), 5×7″ (12.5×18cm), 8×10″ (20×25cm), and 11×14″ (28×36cm). Also, some cameras can be adapted to use various sizes of roll film.

THE COUPLED RANGEFINDER VIEWFINDER CAMERA
The coupled rangefinder viewfinder camera (Figure 18) uses separate lens systems to view and photograph the subject. The rangefinder permits accurate focusing of the image while the subject is examined through the viewfinder. Modern rangefinder cameras are usually equipped with an exposure meter.

The rangefinder system, as its name indicates, is coupled to the picture-taking lens through a series of gears so that focusing the image in the viewfinder also focuses the image on the film when it is exposed. The system consists of two viewing lenses located a distance apart on the camera body. The image formed by one lens is superimposed on the image formed by the second lens. As a result, when the image is out of focus, two distinct images appear in the viewfinder. Focus is achieved by rotating a focusing ring coupled to the picture-taking lens until the two distinct images merge to form a single image in the viewfinder.

Most rangefinder cameras have external exposure meters that measure the overall brightness of a scene, although one camera manufacturer offers behind-the-lens metering. Also, depending on the manufacturer, film exposure may be automatically or manually controlled. Finally, the shutter may be of focal-plane design, which allows lenses to be interchanged while the film remains

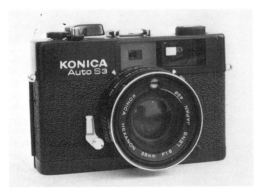

18. *Coupled rangefinder viewfinder camera.*

shielded by the shutter or, as is more common, a be-tween-the-lens leaf shutter mounted in a noninterchangeable lens may be used.

ADVANTAGES. The rangefinder is particularly useful for general, noncritical photography. It allows precise image focusing, even in situations where light levels are low, and, as just indicated, if the camera is equipped with a focal-plane shutter, it will accept interchangeable lenses. In addition, the rangefinder allows continuous viewing of the subject, even as the picture is being taken, and the simple design of the camera makes it relatively easy to repair.

DISADVANTAGES. The chief disadvantage of the rangefinder camera, however, is the parallax error exhibited by the rangefinder itself. This is especially true at close focusing distances where the images seen and photographed are markedly different. There are also other disadvantages: The viewfinder only presents a visual approximation of the image as it will actually be photographed. Most rangefinder cameras do not accept interchangeable lenses. The effect of changing the lens aperture (which results in increased or decreased depth of field) cannot be checked visually in the viewfinder. Finally, exposure systems commonly used in rangefinder cameras that are automatic cannot be operated manually, preventing the critical exposure control essential in photographing works of art.

FORMATS. The rangefinder camera is available in: 110, 35m and 120/220 roll film formats.

THE TWIN-LENS REFLEX CAMERA

The twin-lens reflex (TLR) camera (Figure 19) employs separate viewing and picture-taking lenses mounted on one panel. The picture-taking lens alone contains a leaf shutter and a diaphragm.

A fixed mirror reflects the image transmitted by the viewing lens upward to a ground-glass viewing and focusing screen that corresponds exactly to the size of the final film image. With a standard TLR camera, the image is seen on the ground glass as a mirror image, reversed from left to right. A folding metal hood shades the screen from ambient light and holds a magnifier for critical focusing.

A pentaprism, if available, can be mounted above the ground glass when the folding hood is removed. The pentaprism corrects the image reversal on the screen and allows the photographer to use the camera at eye level. Without a pentaprism, the camera is generally used at waist level.

In general, twin-lens reflex cameras do not incorporate an exposure meter in their design. Therefore, a hand-held exposure meter is required to calculate lens apertures and shutter speeds.

A few TLRs, however, accept interchangeable lenses. In this case, the panel holding both the viewing and picture-

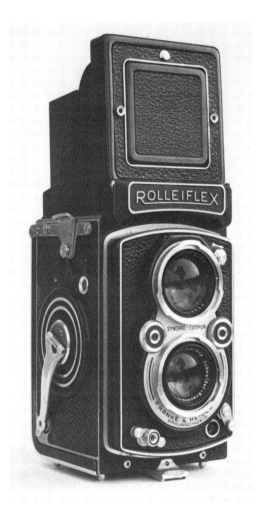

19. Twin-lens reflex camera.

20. Direct vision viewfinder camera.

taking lenses is replaced as a unit and the lenses are matched so that the images seen and photographed correspond to one another. While the lens panel is changed, a slide is lowered within the camera to protect the film from exposure. This is necessary because the shutter normally shielding the film is located within the picture-taking lens.

ADVANTAGES. The twin-lens reflex camera is simple in design and less prone to mechanical breakdown than, for example, the more complex SLR. In addition, the large ground-glass viewing screen makes composition and focusing of the subject easy. Also, the viewing system allows continuous viewing of the subject, and the TLR is available in both roll-film and sheet-film models.

DISADVANTAGES. The main disadvantage in the TLR camera is that the viewing system suffers from parallax error because the viewing and picture-taking lenses are located at different points on the camera body. Also, as previously mentioned, most twin-lens reflex cameras do not incorporate an exposure meter in their design or accept interchangeable lenses. In addition, the left-to-right reversed mirror image on the ground glass may make the camera awkward to use.

FORMATS. Twin-lens reflex cameras are available in: 120/220 roll film and 4×5″ (10×12.5 cm) sheet film formats. Some models can be converted to use 35mm film as well.

THE DIRECT-VISION VIEWFINDER CAMERA
The direct-vision viewfinder camera (Figure 20) is among the simplest cameras made. It has two separate lens systems: one to view the subject directly, and the second to photograph the subject. The viewfinder image approximates the area of the subject actually photographed by the picture-taking lens.

The picture-taking lens usually has a wide view of the subject to be photographed and is permanently mounted on the camera body. The picture-taking lens alone contains the shutter and diaphragm. It cannot be interchanged with different types of lenses. The simplest, and least expensive, direct-vision cameras have lenses of fixed focus. Fixed-focus lenses focus acceptably from about four feet (1m) to infinity without manipulation simply because of the design of the lens. No fine-focusing control is possible with a fixed-focus lens.

An exposure meter mounted on the outside of the camera body measures the overall brightness of the subject. Some cameras automatically adjust the lens aperture and/or shutter speed for "proper" exposure of the film. Others offer a limited number of shutter speed or lens aperture selections. The most basic direct vision cameras do not have an exposure meter and use a shutter speed and aperture preset by the manufacturer.

ADVANTAGES. The direct-vision camera is useful for general, noncritical photography. Its viewing system

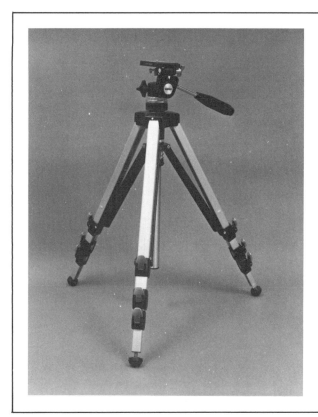

allows the photographer to view the subject continuously. The camera is simple to operate and easy to repair.

DISADVANTAGES. Like the TLR camera, the direct-vision viewfinder camera suffers from parallax error in the viewing system. In addition, the camera lacks an accurate focusing system and manual exposure controls. It is also unable to accept interchangeable lenses.

FORMATS. Direct-vision cameras are available in virtually all film formats, including: 110, 126, 35mm, and 120/220 roll film, 2¼×3¼"(57×83mm) and 4×5" (101×125mm) sheet film, and Polaroid films.

SUMMARY OF RECOMMENDATIONS

The 35mm single-lens reflex camera is recommended for photographing works of art. It offers viewing accuracy, lens interchangeability, full focusing and exposure control, and intermediate image size. Furthermore, a large range of films is available in color and black-and-white. In addition, a wide assortment of different types of lenses are available, permitting you to select the lens best suited to the subject matter and working conditions. In short, the 35mm SLR is a flexible and affordable camera.

As for the film to use, the 35mm format slide is ideal for presenting your work to art galleries and organizations and for projection and, for all practical purposes, has become the standard format for the presentation of works of art. Therefore, it is assumed in writing this book that most readers own or have access to a 35mm non-automatic SLR camera with a built-in exposure meter that accepts interchangeable lenses.

21. A tripod provides steady support for the camera. Rubber tips at the base of each tripod leg (left) *prevent slippage on smooth floors. Retracting the rubber tip* (above) *reveals a metal spike that is generally used when photographing outdoors.*

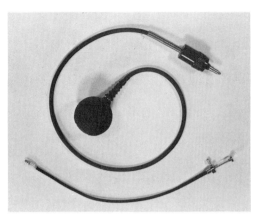

22. *Pneumatic* (top) *and mechanical* (bottom) *shutter release cables prevent the camera from being inadvertently moved or shaken when the shutter is released.*

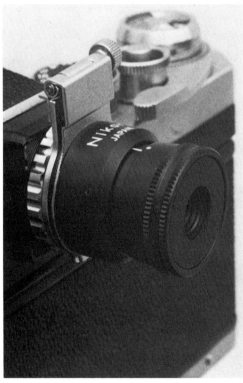

23. *A viewfinder magnifier attaches to the viewfinder and enlarges a portion of the viewfinder image for critical focusing.*

The direct-vision ground-glass view camera, on the other hand, is a professional camera. No fixed-body camera is as flexible as the view camera, and therefore it is ideal for photographing works of art in color and black-and-white. Furthermore, the 4×5″ (101×125mm) transparency produced by the view camera is widely used for reproducing works of art for publicity purposes. Thus, for the uncompromising, technically oriented artist, the view camera is a likely choice. It should, however, be used in addition to, rather than instead of, the 35mm SLR.

As for the rangefinder, twin-lens reflex, and direct-vision viewfinder cameras, the parallax error in these systems makes it impossible to see the subject exactly as it will be recorded on the film. Therefore, in spite of their usefulness in other fields of amateur and professional photography, cameras using such viewing systems are not recommended for photographing works of art, where viewing accuracy is essential.

CAMERA ACCESSORIES

Camera and independent photographic equipment manufacturers offer many useful accessories, several of which are particularly useful for photographing works of art:

TRIPOD. A tripod (Figure 21) is essential for steadying the camera while the film is exposed. It also makes precise viewing and framing of the object in the viewfinder an easy, repeatable task. A sturdy tripod with a rising center post is therefore recommended.

SHUTTER RELEASE CABLE. A shutter release cable (Figure 22) insures that the camera is not inadvertently moved when the shutter is released by preventing the movement of the fingers from touching the camera itself.

VIEWFINDER MAGNIFIER. A viewfinder magnifier (Figure 23) is used to enlarge a portion (usually the center) of the viewfinder image for critical focusing. It is attached to the eyepiece at the rear of the camera.

LOUPE. A loupe (Figure 24) is used on the ground glass of a view camera to enlarge the image for critical focusing. It can also be used for critical examination of negatives, slides, and transparencies.

QUESTIONS AND ANSWERS
Which brand of 35mm SLR is best?
There is no "best" brand of 35mm single-lens reflex camera. Manufacturers have designed their cameras to perform well under a variety of conditions and to compete in price with one another. For these reasons, there are no major design differences among popular brands of 35mm cameras that would make one company's products superior to others.

It is notable, however, that only one 35mm SLR—Nikon—allows the photographer to see the image in the viewfinder *exactly* as it will be recorded on the film. Although the single-lens reflex viewing system of other cameras allows the photographer to see the object as it will be photographed, a significant portion of that image

is not transmitted through the viewfinder, although it is still recorded on the film. Because it is important that objects be located on the film properly, it is disconcerting to discover that images thought to be accurately centered or positioned in the viewfinder are not accurately centered on the film.

To learn exactly how much of the view recorded on the film is not seen in the viewfinder, you will have to perform a series of tests on your equipment.

These tests (detailed in Chapter 5) will enable you to discover if there is a significant difference between what is seen and what is photographed by your particular camera. Once the extent of the problem has been determined, you will then be able to adjust your equipment to accurately place the image on the film.

What about compact and automatic cameras?
Compact or automatic 35mm cameras are relatively expensive and are of no particular advantage to photographers of art. In fact, totally automatic cameras should be avoided because they do not allow full exposure control by the photographer. In other words, it is of no advantage to own the "smallest, lightest, most compact" SLR ever made.

What is a system camera?
The heart of the system camera is the camera body. The manufacturer makes a system of accessories which are attached to the camera body according to the needs of the photographer. These accessories include: interchangeable lenses, motor drives (which power the film through the camera at several frames per second and automatically expose the film), film packs (which hold long lengths of film), and microscope adapters (which attach the camera body to a microscope). But remember, it is not necessary to own a camera designed to fit a manufacturer's "system" in order to photograph art.

Should I buy new or used equipment?
A used camera can be an expensive mistake because in buying it you run the risk of purchasing someone else's headache. Also, used equipment is not usually covered by a warranty, so you must pay for any repairs that are needed. Reputable stores, however, may permit the camera to be tested thoroughly in the store before it is purchased. Do not buy equipment that cannot be tested prior to purchase.

A new camera, on the other hand, is under the protection of a warranty, which therefore gives you the opportunity to test the camera thoroughly and note any defects. However, the warranty only covers defects in material and workmanship; it will not cover damage caused by the user.

24. *A loupe is a magnifier used on the ground glass of the view camera to enlarge the image for critical focusing. It can also be used for critical examination of negatives, slides, and transparencies.*

2. THE LENS

The lens transmits light reflected from the subject to form a light image of the subject that is recorded on the film within the camera body. In addition, the lens permits the photographer to control the quantity of light transmitted, the sharpness of the subject and the adjacent environment, and the perspective of the subject in relation to its environment. The results are determined by the focal length of the lens and the size of its aperture.

FOCAL LENGTH
The focal length of the lens determines how much of a scene will be recorded on the film (Figure 25). The lens' field of view is directly related to its focal length. For example, short focal length (wide-angle) lenses have a wide angle of view and produce images in which subjects appear smaller and farther from the camera and the photographer than they actually are. On the other hand, long focal length (telephoto) lenses have a narrow angle of view and produce images in which subjects appear larger and closer to the camera and the photographer than they actually are.

The camera's "normal" lens has a focal length slightly longer than the length of the diagonal of the square or rectangular film frame produced by the camera. So a 35mm SLR, for example, has a normal lens of 50 or 55mm. But cameras with different film format sizes have normal lenses of different focal lengths. You can see three examples of the relationship between film format size and the focal length of the camera's normal lens in the following table:

FILM FRAME SIZE	NORMAL LENS FOCAL LENGTH
35mm (24 × 36mm)	50mm
2¼ × 2¼"	80mm
4 × 5"	165mm

While a precise method of calculating the focal length of a lens does exist, for all practical purposes, it is the distance from the approximate center of the lens to the film plane when the lens is focused at infinity (∞). That distance is expressed in millimeters or inches and is embossed on the front of the lens barrel (Figure 26).

APERTURE CONTROL
The lens diaphragm forms a variable opening or aperture and is located within the lens barrel between the front and rear lens elements. It is used to control the quantity of light transmitted by the lens to the film and to control depth of field in the image. The aperture control ring or lever on the lens varies aperture size (Figure 27).

A series of numbers (called f/numbers) is embossed on the control ring of the lens diaphragm, and an index mark on the lens barrel indicates which f/number has

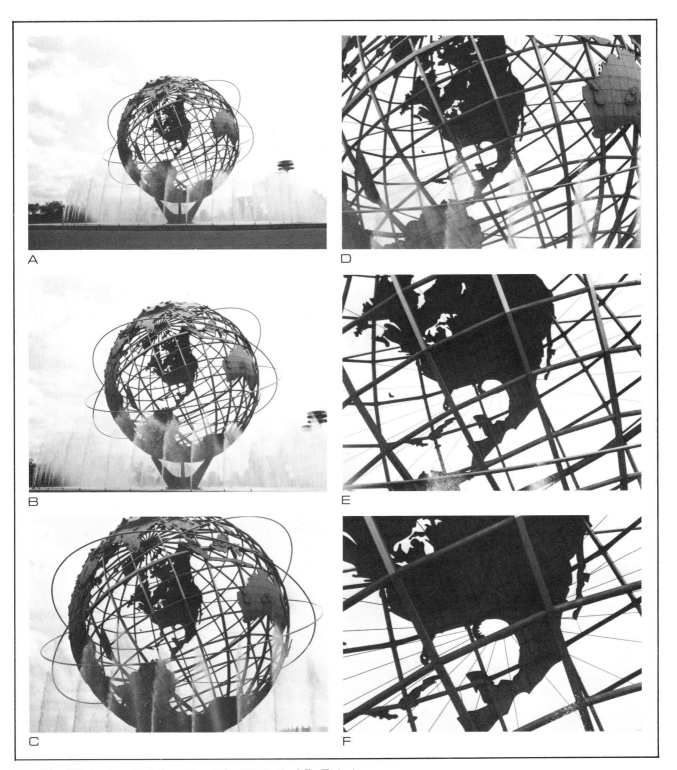

25. The "Unisphere" at the site of the 1964 World's Fair in
Queens, New York, was photographed with lenses of different
focal lengths from the same camera position: (A) 28mm focal
length lens; (B) 35mm focal length lens; (C) 50mm focal length
lens; (D) 80mm focal length lens; (E) 135mm focal length lens;
(F) 200mm focal length lens.

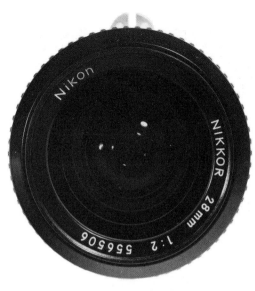

26. *Here is a photograph of a 28mm focal-length lens for a single-lens reflex camera.*

been selected. The control ring may click stop at each number and may also click stop midway between pairs of numbers.

Each *f*/number represents the result of a mathematical comparison of the diameter of the aperture selected with the focal length of the lens. The effectiveness of any aperture in transmitting a specific quantity of light to the film is directly dependent on its distance from the film. The distance of the aperture from the film is based on the focal length of the lens. As the aperture is moved farther from the film, the intensity of light reaching the film diminishes. To maintain an equivalent amount of light as the distance between aperture and film increases, a larger aperture must be used.

The *f*/numbers are a uniform means of identifying the ability of any aperture with any focal length lens to maintain a specific light intensity on the film. Apertures with identical *f*/numbers on lenses of different focal lengths result in identical light intensities on the film.

Each *f*/number represents an aperture—or "stop"—of a specific size for a specific lens. The standard sequence of stops is:

$$f/...1, 1.4, 2, 2.8, 4, 5.6, 8, 11, 16, 22, 32, 45....$$

No one lens has this entire range of stops, and some lenses have other stops (such as *f*/1.8 or *f*/3.5) as well. These stops, however, are not *standard*.

The smaller the *f*/number, the larger the aperture, and the larger the *f*/number, the smaller the aperture. Therefore, decreasing the size of the aperture by one stop (from *f*//5.6 to *f*/8, for example) *halves* the amount of light reaching the film. This is called "stopping down" the lens. On the other hand, increasing the size of the aperture one stop (from *f*/32 to *f*/22, for example) *doubles* the amount of light reaching the film. This is called "opening up" the lens (Figure 28).

Lens *speed* is represented by the maximum aperture available for a specific lens. A lens with a maximum aperture of *f*/1.2 or *f*/1.4 is called a "fast" lens. Apertures of these sizes are usually available only on the camera's normal lens. A lens with a maximum aperture of *f*/3.5 or *f*/5.6 is called a "slow" lens. Wide-angle and telephoto lenses are generally in this category. The terms "fast" and "slow" refer to the shutter speeds required at the maximum aperture of each lens to yield equivalent exposures under identical lighting conditions. The maximum aperture *f*/number is embossed on the front of the lens barrel along with the focal length of the lens (Figure 29).

DEPTH OF FIELD

Depth of field is a zone in front of and behind the subject on which the lens is specifically focused that also *appears* to be in focus in the film image. It is important to remember that the lens is *actually* focused only on the subject. For any particular focal-length lens, the use of

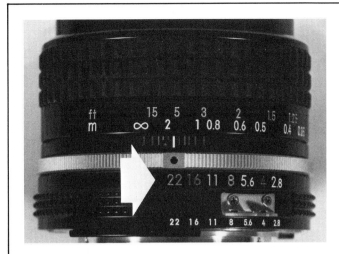

27. *The size of the aperture regulates the amount of light trans-
mitted to the film. Here are photographs of the aperture control
ring for a typical SLR* (left) *and for a typical view camera lens*
(right).

28. *Turning the aperture ring from a larger aperture* (left)
to a smaller one (right) *is called "stopping down" the lens.
Turning the ring in the other direction, from a smaller aperture
to a larger one, is called "opening up" the lens.*

29. *The maximum aperture of a lens is embossed on the lens barrel. Here the maximum aperture is expressed as a ratio (1:2.8) that indicates that the maximum aperture for this lens is f/2.8. This marking system is commonly used on modern lenses.*

small apertures increases depth of field, while the use of larger apertures decreases depth of field (Figure 30).

In addition to the size of the aperture, the focal length of the lens also affects depth of field. For example, for all practical purposes, wide-angle lenses produce the greatest depth of field, while telephoto lenses produce the least depth of field at equivalent apertures and equivalent distances from the subject (Figure 31). Other lenses span the range between these extremes.

The depth of field produced by a particular aperture also varies with the distance of the subject from the camera. Thus depth of field will be shallowest at close focusing distances and deepest at long focusing distances using equivalent apertures (Figure 32).

Depth of field can be determined in advance because most 35mm SLRs permit the photographer to preview the image through the viewfinder and see how it is affected by focal length, lens aperture, and focusing distance. In addition, a depth-of-field scale on the camera lens, when used in conjunction with the focusing distance scale, indicates the depth of field that can be expected for particular aperture and focusing distance combinations (Figure 33).

PERSPECTIVE

In photography, the three-dimensional world is transformed into a two-dimensional image. So the way we see depth and perspective in a photograph is by comparing

30. *Several factors influence depth of field. As you can see from the two photographs above, one factor is the size of the aperture: (left) 50mm lens focused* *at 15 feet (4.5m) at aperture f/2; (right) 50mm lens focused at 15 feet (4.5m) at aperture f/11.*

31. The depth of field is also affected by the focal length of the lens: (left) 28mm wide-angle lens focused at 15 feet (4.5m) at aperture f/11; (right)

100mm telephoto lens focused at 15 feet (4.5m) at aperture f/11.

32. Depth of field is also affected by the distance of the subject from the camera: (left) 50mm lens

focused at 5 feet (1.5m) at aperture f/2; (right) 50mm lens focused at 15 feet (4.5m) at aperture f/2.

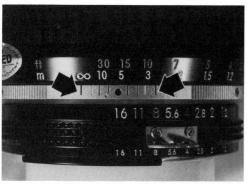

33. *The depth of field scale consists of pairs of lines, one located on each side of the focusing mark on the lens. The scale is located between the focusing distance scale (or focusing ring) and the aperture control ring. Selected apertures are color-coded to correspond to particular pairs of lines on the depth of field scale. To determine the depth of field produced by any aperture at any focusing distance, you must first determine which pair of lines corresponds to the aperture selected by matching their colors, then compare the lines with the distance scale. In this instance, f/16 corresponds to the outermost pair of lines on the scale. In juxtaposition to the focusing distance scale, they indicate that when the lens is actually focused on a subject approximately 17 feet (6m) from the camera, this aperture will produce an area of acceptable focus (depth of field) beginning 9 feet (3.7m) from the camera and extending to infinity (∞).*

the sizes and positions of the objects there with the sizes and positions of objects as we know they look in the real world. Since perspective is directly related to the distance between the camera and the subject, as long as the camera-to-subject distance remains the same, photographs of the same subject taken with lenses of different focal lengths show no change in perspective (Figure 34). The angles of view in the photographs change, of course, as do the sizes of the objects in the image. But object sizes do not change relative to one another; they remain proportionately the same in each image.

On the other hand, using the same lens and changing the camera-to-subject distance instead *will* change the sizes of objects (or portions of a single object) in the image out of proportion to one another and produce an inaccurate rendition of the object at close focusing distances (Figure 35). This effect is called "perspective distortion." Therefore, when photographing three-dimensional works of art of widely different sizes, it is best to change the focal length of the lens in order to maintain relatively the same camera-to-subject distance with similar perspective.

ABERRATIONS

The image transmitted and reconstructed by a single lens element exhibits many faults or "aberrations." Aberrations are inherent, to a greater or lesser degree, in all lenses. However, the use of special lens coatings and multiple lens elements reduces lens aberrations to a very low level.

One aberration that is not controlled by lens coatings or the use of multiple lens elements, and is of particular concern to photographers of art, is *linear distortion*. Linear distortion is the result of the location of the lens diaphragm within the lens barrel. It is manifested in two forms: pincushion distortion and barrel distortion (Figure 36). In each case, straight lines in the subject are rendered as curved lines in the image, except through the horizontal axis and vertical axis of the lens. This effect will be particularly evident when photographing two-dimensional square or rectangular works.

Linear distortion is found, in varying degrees, in wide-angle, normal, telephoto, and zoom lenses, especially when used at close focusing distances. On the other hand, the macro lens, which is specifically designed for use at close focusing distances, does not exhibit linear distortion, regardless of focal length.

LENS TYPES

There are five major types of photographic lenses: wide-angle, normal, telephoto, macro, and zoom (Figure 37). They are distinguished from one another by their focal lengths, maximum apertures, and fields or angles of view. There are also additional differences among these types of lenses. The focal lengths indicated in the descriptions

34. Totem VI *by Charles Reina as photographed with a 50mm lens* (above left) *and a 28mm lens* (above) *from the same camera position. While the angle of view has changed, the perspective has remained the same, as is shown in the enlargement of the image produced by the 28mm lens* (left).

35. Changing the position of the camera to produce images of similar size with lenses of different focal lengths causes a change in perspective. The 50mm lens image (left) and the 28mm lens image (right) are now quite different representations of the same subject. Note that the size of Totem IV *in relation to the landscape has changed, making the object appear much larger in scale in the 28mm image than it actually is.*

that follow are those applicable to 35mm format cameras.

WIDE-ANGLE LENS

The wide-angle lens has a wide field of view, and objects seen in it appear to be smaller and farther from the camera than they do to the eye from the same position as the camera. Common wide-angle lens focal lengths are 20mm, 24mm, 28mm, and 35mm. Wide-angle lenses with focal lengths shorter than 20mm are called "fisheye" lenses. Because of the distortion they produce, they are unsuitable for photographing works of art.

Wide-angle lenses produce marked perspective distortion at close focusing distances. This is a distinct disadvantage in photographing art where, to produce as large an image of the subject as possible on the film, you must bring the camera and the object to be photographed relatively close to one another. Therefore, when you compare the normal perspective produced when photographing the same object with a normal lens at a greater camera-to-subject distance with the results obtained with a wide-angle lens, the perspective of the wide-angle lens will appear abnormal or distorted in the final image (Figure 38). Again, this distortion is not due to any abnormality in the lens, but is directly related to the comparison of the eye's perception of perspective and the perspective produced by the wide-angle lens.

You will find the wide-angle lens to be especially useful when photographing large works in close quarters or when the dramatic impact of a wide field of view enhances the subject. But never use a wide-angle lens when another lens of longer focal length, which would produce minimal perspective distortion, can be used.

NORMAL LENS

The normal lens has a field of view that most closely approximates that of the human eye. Common focal lengths are between 48mm and 55mm. The field of view of the normal lens is smaller or narrower than that of the wide-angle lens but greater than that of the telephoto lens. The normal lens also has a shallower depth of field than the wide-angle lens at equivalent apertures. A substantial increase in depth of field can be obtained, however, by decreasing the size of the aperture.

Perspective distortion is minimal when the normal lens is used at a reasonable distance from the subject. However, at close focusing distances, perspective distortion increases and may become objectionable.

TELEPHOTO LENS

The telephoto lens has a narrower field of view than either the wide-angle or the normal lens. Objects appear closer to the camera and larger in the image than they do to the eye from the same position as the camera. Telephoto lens focal lengths span a range from 85mm to 2000mm, but the focal lengths most commonly used when photographing works of art are 85mm, 100mm (or 105mm), and 135mm.

36. There are two types of distortion: pincushion distortion (top) *and barrel distortion* (above).

37. Here are a group of typical 35mm SLR lenses (clockwise): 135mm, 35mm, 200mm, and another 35mm lens.

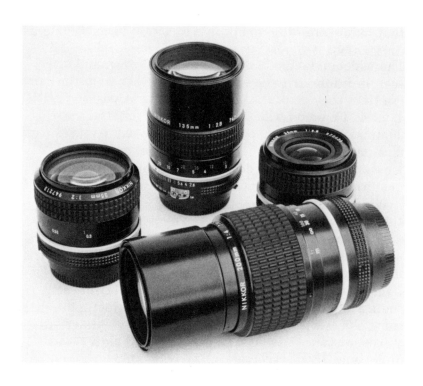

Telephoto lenses with longer focal lengths are especially useful when the subject being photographed is inaccessible or when it is neccessary to remain at great distances from the subject so as not to disturb it, as in nature photography. But since, in most instances, works of art are accessible, the use of long focal-length telephoto lenses only increases camera-to-subject distance unnecessarily.

The depth of field produced by the telephoto lens is shallower at equivalent apertures than those of the wide-angle and the normal lens, but small-to-moderate increases in depth of field are possible by decreasing the size of the aperture. Also, because telephoto lenses have limited close-focusing ability, it may not be possible to produce images that fill the film frame when photographing small objects. (Close-focusing ability varies with focal length and manufacturer.)

The chief advantages of the telephoto lens are that it allows the photographer to maintain a reasonable working distance from the object (away from the object itself and, perhaps, studio lights) and that it produces a natural perspective. In addition, its limited depth of field allows the object being photographed to be isolated from competing or distracting backgrounds.

MACRO LENSES
Macro lenses have an angle of view varying with focal length. They are generally available in focal lengths of 50mm or 55mm, and 100mm or 105mm, depending on the manufacturer. Macro lenses are specifically designed for photographing small objects at close focusing distances with minimum distortion. By themselves, they are capable of producing one-half life-size images of small objects on the film, and with extension tubes matched to the lens

they can achieve life-size images of very small objects. The macro lens is free of linear distortion and is particularly well suited to photographing two-dimensional flat objects and small three-dimensional objects.

Macro and so-called "close-focusing" lenses should not be confused with one another. "Close-focusing" lenses are not true flat-field macro lenses and should not be thought of as such. You should be alert to this, because some manufacturers identify close-focusing lenses as macro lenses when in fact they are not true macro lenses.

Although macro lenses generally have small relative apertures of above $f/3.5$, this is of no particular consequence since most exposures in photographing art will be made at smaller apertures than this under usual lighting conditions.

ZOOM LENS

The zoom lens combines the flexibility of several lenses of different focal lengths into one lens. The focal length of a zoom lens can be changed continuously between fixed minimum and maximum focal lengths while the subject remains in focus. Focal lengths of zoom lenses are expressed in terms of the minimum and maximum lengths available, such as 43–86mm or 80–200mm. A wide variety of zoom lenses is currently available in numerous focal length ranges.

The interior components of the zoom lens are complex, and designers of such lenses have to some extent compromised their image quality in favor of their flexibility. As a general rule, the image quality of lenses of fixed focal length is superior to the image quality of a zoom lens set at the same focal length. Also, zoom lenses have smaller maximum relative apertures and are usually longer and heavier than any of the single focal-length lenses encompassed in their ranges.

The chief advantages of zoom lenses are their portability and flexibility. It is easier to carry a single zoom lens than three or four fixed focal-length lenses. It is also easier to have one lens with which image size can be varied to compose the subject in the viewfinder. However, zoom lenses were not designed to meet the needs of photographers of art, who rarely need such features in the lens itself.

LENS ACCESSORIES

The front of each lens barrel and each lens accessory is threaded so that each accessory can be screwed to the front of the lens. Accessories are available in a variety of different diameters to fit most lenses. If you plan to use the accessories on lenses of different thread sizes, buy either the largest size needed, or "series" sizes. (Series filters are not threaded, but are inserted in threaded holders whose thread size is matched to each lens as necessary.) You can also use step-down rings to attach larger threaded accessories to smaller size lens barrels. But

38. This basket by Alice Wansor was photographed with a 55mm macro lens (left) and a 28mm wide-angle lens (right) to produce images of similar size on the film. Note the perspective distortion caused when the camera was relocated to produce an image equivalent to the 50mm lens image with the 28mm lens.

never use smaller accessories on larger lens barrels because the smaller accessories may interfere with the light transmitted by the lens. Photography dealers will be happy to help you determine whether threaded or series accessories will be of most use to you, based on the lenses for which they are required.

Among the many lens accessories available, the following are particularly useful:

LENS SHADE

The lens shade (Figure 39) prevents stray light, which might cause flare in the image, from reaching the film. Flare appears as white, washed-out spots, areas, or streaks in transparencies or prints.

FILTERS

The range and types of filters available are extensive (Figure 40). Color-correcting filters can be used to adjust the color of available light to match the color response of the film. Contrast filters are used in black-and-white photography to enhance or eliminate one or more colors in the subject. The use of filters will be discussed in more detail in subsequent chapters.

POLARIZER

A polarizer is useful in both black-and-white and color photography for a variety of reasons. It organizes disorganized reflected or refracted light waves so that they travel in parallel lines, thus controlling or eliminating some types of reflection and glare (Figure 41, see also color section). In color photography, the polarizer is the only device that can deepen and enrich the color of the sky in a landscape without causing a color change in other portions of the subject. And eliminating some reflections and glare also enriches the colors in the object being photographed.

LENS CLEANERS

Lens cleaning fluid and lens tissue are used in combination to remove grease marks and fingerprints from the outside surfaces of the glass elements of the lens (Figure 42). But you must follow the manufacturer's directions to avoid damaging the lens through excess fluid or improper wiping.

BLOWER BRUSH

A blower brush is used to remove dust from lens surfaces and the interior of the camera body (Figure 43).

QUESTIONS AND ANSWERS

Is there a significant difference in the quality of lenses produced by camera manufacturers and other lensmakers?
Although there may be some technical differences that are reflected in test reports published by major photography magazines, the overall level of lens quality is now so high that discernible differences in quality can only be measured by using sophisticated equipment and testing procedures. By following the testing procedures outlined in Chapter 5, you should be able to determine the general overall quality of your lenses. But if you feel that a particular lens may not meet your requirements, before you purchase it, ask to be allowed to test the lens.

Do older, uncoated lenses produce inferior pictures?
Lens coating increases light transmission through the glass lens elements, reduces some forms of aberrations, and permits greater subject contrast to be transmitted to the film image. In a studio setting, uncoated lenses should perform at about the same level as coated lenses. Outside the studio, however, where light conditions and light sources cannot be easily controlled and the contrast range may be greater, coated lenses will perform with fewer apparent aberrations, such as lens flare.

I have a 50mm f/2 normal lens for my 35mm SLR. Would it be prudent to replace it with a faster f/1.2 lens?
The best aperture to choose within the range available for any lens is roughly three or four stops below the maximum or largest available aperture. An $f/1.2$ lens is used to best advantage in low-light situations where a higher shutter speed must be used to "freeze" the action of the subject or where conditions would not otherwise permit proper exposure of the film. But image quality is somewhat poorer at $f/1.2$ than at smaller apertures on an $f/1.2$ lens. Hence, given the more normal lighting conditions likely to be encountered in photographing art, there is no need to have an expensive $f/1.2$ lens on hand when an intermediate aperture available on an $f/2$ lens will be used.

Can I use a set of close-up accessory lenses with my normal lens rather than purchase a macro lens?
Close-up lenses were not designed to replace the macro

39. A lens shade prevents stray light from striking the front element of the camera lens.

40. Filters are used to control subject contrast in black-and-white images or to correct color rendition in color images.

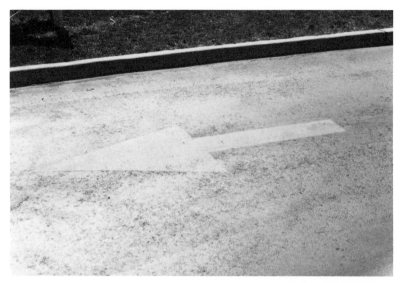

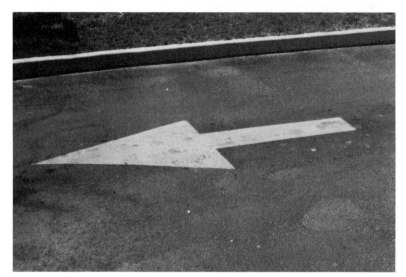

41. *A polarizer is useful in black-and-white photography because it controls many types of light reflections and deepens sky color without causing value changes in the subject* (above). *Without a polarizer* (top right), *light reflected from the surface of a driveway hides a painted arrow. By using a polarizer* (right), *you can eliminate this form of reflection. Examples of a polarizer's use in color photography are shown on pages 81–83.*

lens. Their purpose is to allow the photographer who only occasionally photographs small objects to do so with the camera's normal lens. They work adequately with very small objects, such as coins or postage stamps, but are not suited to photographing other objects.

What is the difference between an "automatic" and a "preset" lens?

Automatic lenses are coupled with the camera's exposure system so that changes in aperture settings register both in the information display area of the viewfinder and in the exposure calculating system itself. The actual size of the aperture remains wide open until the photograph is taken. At that instant, the diaphragm closes to the selected aperture. The image seen through the viewfinder remains bright and clear throughout focusing and composition.

Preset lenses are not automatically coupled with the camera's exposure system. The diaphragm must be closed to the aperture required in order to cause a change in both the exposure information displayed in the viewfinder and in the exposure calculating system. The amount of

light that passes through the lens and into the viewfinder system dims as the aperture is reduced in size.

How can I easily determine the camera-to-object distance required with a particular lens and a specific object?
Follow this simple procedure:

(1) Measure the work and write down its height and width.

(2) Multiply the shorter of the two dimensions by 1½.

(3) Compare this figure with the second dimension and select the larger of the two.

(4) Multiply the larger number by the following "focal length factors" to determine the camera-to-object distance required for each of these recommended lenses:

LENS	FOCAL LENGTH FACTOR
50mm normal or macro	1.55
85mm telephoto	2.55
105mm telephoto or macro	3.1
135mm telephoto	4.1

These distances are approximate and were determined by experimentation with a Nikon F camera and Nikkor lenses of the focal lengths listed above. (Lenses were provided courtesy of Nikon, Inc., Garden City, N.Y.) Other cameras may have to be used at slightly lesser or greater distances. These distances do not include space for a tripod, which should, of course, be used at all times.

Overall, which type of lens is recommended for photographing two- and three-dimensional works of art?
For two-dimensional objects, such as paintings, a macro lens is best. For three-dimensional objects, like sculpture, a moderate telephoto (85 to 105 mm) is preferable.

42. *Lens cleaning fluid and lens tissue are used to clean the exposed glass surfaces of the lens.*

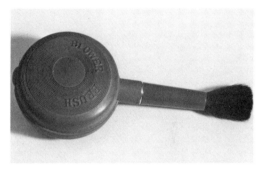

43. *A blower brush removes dust that may collect on lens surfaces or within the interior of the camera body.*

3. LIGHT AND LIGHTING

Light is the essential element in photography that gives form and color to objects, but its properties must be understood and controlled by the photographer not only to achieve properly exposed images but also to make those images faithful and informative renditions of the original work. The controlled, sensitive manipulation of light in relation to both the objects themselves and their photographic renditions is one key to successfully photographing works of art.

COLOR TEMPERATURE

Light is identified first by its color temperature and second by its source. Light is a form of energy emitted when, for example, a tungsten filament is heated or a gas within a glass tube is "excited" by passing an electric current charge through it. The color temperature of light is determined by heating a black metal body (which neither emits or reflects light when cold). At the point where the metal emits a specific color of light, the temperature of the metal is measured and the light is identified by that temperature in Kelvins or degrees Kelvin.

As the temperature of the metal increases, the color of the light that is emitted changes from red through orange, to yellow, to green, then to blue. The cooler color temperatures are at the red end of the color spectrum, the hotter at the blue end. While it is common to think of red as "hot" and blue as "cool" colors artistically, these descriptions are reversed when discussing light color temperature.

Pure white light consists of equal proportions of red, green, and blue light—the primary colors. But other types of light that are also subjectively called "white" light may contain larger proportions of one or two of these primary colors.

Therefore, to compensate for the various proportions of red, blue, and green light contained in specific types of "white" light, specific types of color film have been developed. Listed below are the light sources commonly used when photographing works of art and the types of film with which they are properly matched:

LIGHT SOURCE	COLOR FILM
3200K tungsten studio light	Type B, 3200K
3400K tungsten photoflood light	Type A, 3400K
5500K daylight	Daylight
5500K electronic flash	Daylight

Color films can be used with light sources other than those for which they are specifically balanced by placing light-balancing filters either over the light source or in front of the lens. But as a general rule, the use of such filters is not recommended. It is much better to use only

films and light sources that are designed for one another.

LIGHT SOURCES
In addition to the color temperature of the light, light sources can be further categorized as either continuous or intermittent. Both can be used to photograph works of art, though each has advantages and disadvantages.

CONTINUOUS LIGHT SOURCES
Continuous light sources include incandescent bulbs, which burn continuously when lit, and sunlight.

ADVANTAGES. The advantages of using continuous light source are that: (1) The effect of a particular lighting arrangement can be clearly and continuously seen, and changes can be made prior to film exposure. (2) Subject contrast (the measured difference in reflectance between light and dark areas of the subject) can be determined exactly in advance of film exposure. (3) Investment in equipment is modest and expense per exposure is low.

DISADVANTAGES. There are also disadvantages associated with continuous light sources: Natural daylight conditions are difficult to control and difficult to repeat from day to day, week to week, or month to month. Also, the actual color temperature of daylight, which is a mixture of sunlight and skylight, varies according to the time of day and year, and with atmospheric conditions.

There is also a disadvantage in the use of incandescent lamps. The tungsten filament in these lamps is vaporized during use and is deposited on the relatively cool inner surface of the bulb. In time, this causes the bulb to darken and results both in decreased light intensity and uneven illumination. In addition, the color temperature of incandescent bulbs changes as they are used. This is especially evident in bulbs approaching the end of their rated hourly usefulness.

An alternate approach to tungsten lighting is tungsten-halogen or quartz-iodide lighting. The tungsten-halogen bulb consists of tungsten filament in a quartz tube filled with a halogen gas. Unlike conventional tungsten bulbs, as the tungsten filament in the quartz-iodide bulb is vaporized, it combines with the halogen and is redeposited on the filament. This extends bulb life and produces a more consistent color temperature throughout its extended life. The higher initial cost of quartz-iodide lighting is generally offset by longer bulb life and more consistent color temperature and light intensity.

INTERMITTENT LIGHT SOURCES
Intermittent light sources include electronic flash units and flashbulbs.

ADVANTAGES. The advantages of using intermittent light sources are that they produce less heat than studio lights, they consume less electricity than studio lights, and they can be used with daylight film in the studio.

DISADVANTAGES. There are disadvantages, too. Intermittent light sources not equipped with incandescent

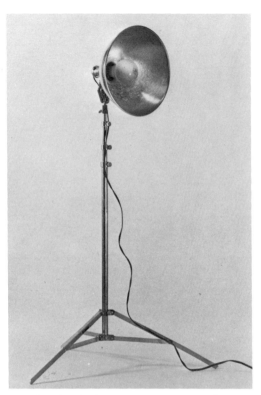

44. *Studio lighting equipment: reflector, lamp socket, bulb, and light stand.*

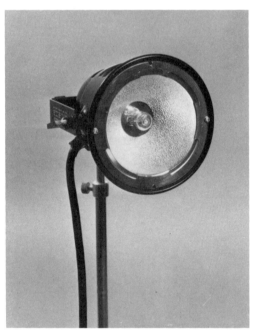

45. *Tungsten-halogen lighting equipment: reflector and socket housing, tungsten-halogen lamp, and light stand.*

modeling lights do not permit accurate judgment of their lighting effect and are, therefore, more difficult to use than continuous light sources. Although electronic flash units incorporating modeling lights do allow the effect of the flash to be judged in advance of film exposure, such units are generally used only in a professional photography studio, because they are expensive. Another intermittent light source, a flashbulb, is generally used on the camera itself, making the light they produce difficult to control. This, coupled with their expense, makes them of little use when photographing art.

EQUIPMENT REQUIRED FOR VARIOUS LIGHT SOURCES

The equiment required to photograph works of art is based on the specific light source illuminating the object to be photographed and the degree to which the light must be controlled. In selecting a light source, you should consider its appropriateness to the work being photographed and keep in mind the working conditions available to you.

DAYLIGHT

The equipment used with daylight illumination is primarily limited to controlling the quality of the light. Daylight conditions range from full sun with blue sky to totally gray and overcast. The quality of light will change as atmospheric conditions and the relative positions of the sun and the work change.

INCANDESCENT LAMPS

Incandescent studio lighting equipment includes: two to four 10″ or 12″ (25 or 30cm) wire-brushed, satin, or matte aluminum reflectors with lamp sockets; one 3200K or 3400K tungsten bulb of 250 or 500 watts for each reflector; one telescoping light stand for each reflector to control the height and position of each light; and extension cords to connect the lights to nearby electrical outlets (Figure 44).

TUNGSTEN-HALOGEN LAMPS

To use tungsten-halogen lamps, replace the aluminum reflectors and 3200K or 3400K bulbs with tungsten-halogen lamp housings and bulbs. The remaining equipment requirements are the same (Figure 45).

ELECTRONIC FLASH

Electronic flash equipment is available in units suitable for studio or field work. While not recommended for beginners, electronic flash can be successfully used by advanced amateurs who know how to control the light it produces.

The equipment required for electronic flash includes: two to four flash units, each with a guide number (GN) of 30 to 50 with ASA 25 film; a power source; flash synchronization cords; slave synchronizers for units not connected directly to the camera or to one another; and light stands (Figure 46).

CONTROLLING THE LIGHT SOURCE

Regardless of the light source selected, the light produced must be controlled in accordance with the requirements of the material being photographed and the final photographic image sought. Here is a selection of light-control devices commonly used when photographing art:

REFLECTORS

Panels of cardboard or similar material covered with white paper or dull aluminum foil are used to reflect light indirectly onto the subject (Figure 47). These are especially useful outdoors to reflect sunlight into areas of deep shadow on sculpture.

BARNDOORS

Barndoors are rectangular pieces of metal that are attached to the reflector and control the direction and width of the beam of light produced by floodlights (Figure 48). They are made of heat-resistant, lightweight metal and serve as "doors" that swing into or away from the path of light. They are useful in preventing light from striking the lens and in separately controlling background and subject illumination.

LIGHT TENT

A light tent is an enclosure of white light-diffusing material or paper that is lighted from outside (Figure 49). Objects placed within the enclosure have virtually no shadows. A small hole in the material allows the camera lens to enter the tent in order to take the photograph.

POLARIZING MATERIAL

Polarizing material in sheet form is placed in front of light sources (Figure 50). This can be used in conjunction with a polarizer mounted on the camera lens to eliminate or control reflections and surface glare. The material reduces light levels, though, and thus requires larger apertures or longer exposures.

DIFFUSION MATERIALS

Diffusion materials can consist of a plastic disk mounted on the reflector, cotton sheets, Fiberglas gauze, or any other material that diffuses the light in its path to the subject and produces shadows that are softer than those from direct light (Figure 51).

QUALITIES OF LIGHT

Light is both absorbed and reflected, in varying degrees, by the objects and surfaces it strikes. Absorption and reflection of light affect the colors perceived by the eye and recorded on color film. They also affect the relative monochromatic brightness values recorded on black-and-white film. The manner in which light is reflected from the surfaces of objects can be described by the terms *specular* and *diffuse*.

SPECULAR REFLECTION

Specular reflection is characteristic of highly polished or glassy surfaces (Figure 52). It may include the light from the light source(s) and light reflected from adjacent ob-

46. Electronic flash lighting equipment: flash unit, synchronization cord to connect the flash unit to the camera, and light stand.

47. Cardboard reflectors are cheap and utilitarian light controlling devices, seen here covered with dull aluminum foil and white paper.

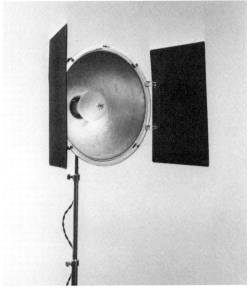

48. Barndoors attach to studio lights to control the spread of the beam of light projected by the reflectors.

49. *A light tent surrounds the object being photographed. When lighted from without, it provides virtually shadowless illumination within. A hole or other entrance in the tent allows the lens of the camera to enter the tent so the work(s) within can be photographed.*

jects and surfaces, which is in turn reflected from the mirrorlike surface of the work (Figure 53). Specular reflections can hide the color and character of the object and produce an inaccurate photographic rendition.

DIFFUSE REFLECTION

Diffuse reflection is characteristic of textured surfaces (Figure 54). It is not as easily identified as specular reflection because it is not as obvious or obtrusive. Nevertheless, it may slightly obscure the color and character of some works. Under most circumstances color rendition will remain reasonably correct. Careful lighting and light control can limit both specular and diffuse reflections so that the work is accurately rendered.

LIGHT ABSORPTION

Surfaces, textures, or colors that *absorb* much of the light that strikes them appear dark, while those that *reflect* much of the light that strikes them appear light. An object seen under white light—which really contains all the colors of the spectrum—appears a particular color because that color is reflected back to our eyes while the other colors of the spectrum are absorbed by the object. For example, a green dress appears green because all colors except green are absorbed, and only the green wavelength is reflected.

DIRECT LIGHT

The selection and control of the light source also deter-

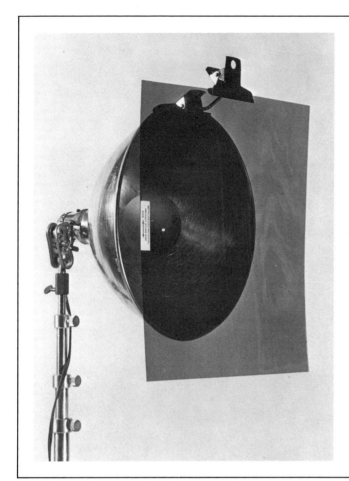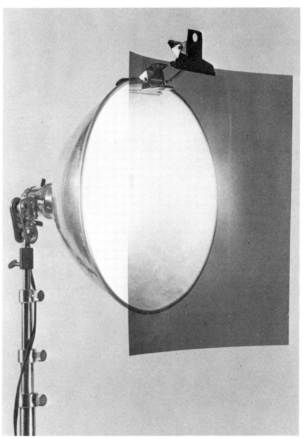

mines the quality of the light. Direct light produces harsh, sharply defined shadows. When photographing highly polished works, glaring "hot spots" or bright highlights are usually evident (Figure 55). Direct light also produces an apparent increase in contrast between brightly lit and deeply shadowed areas of the work (Figure 56). Areas of similar color or tone will appear as two different tones to the eye and in the photographic image if they appear in both brightly lit and shadowed areas. This effect may detract from or add striking qualities to the work.

Direct light is easily produced, but you must be careful not to create a confusing array of shadows when using more than one light source (Figure 57). Direct light can be used most advantageously where the interplay of shadows is important to or part of the substance of the work, for example in showing heightened surface texture, relief, and impasto.

DIFFUSE LIGHT
Diffuse light produces soft-edged shadows or no shadows (such as under the light tent) and is produced by large light sources (such as an overcast sky) or by reflectors from which light is reflected or "bounced" indirectly toward the subject. No glaring "hot spots" or bright highlights will be evident under diffuse lighting, although large whitish areas of specular reflection on highly pol-

50. Sheets of polarizing material placed in front of studio lights can be used in conjunction with a polarizer attached to the camera lens to provide maximum reflection control on nonmetallic surfaces. The sheets of polarizing material do not provide reflection control in themselves, however, and are not designed for use in front of the camera lens.

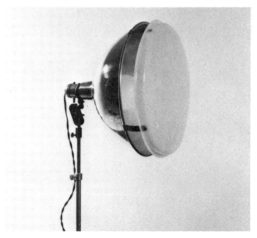

51. A diffuser placed in front of the light source scatters the light and softens the otherwise harsh shadows produced with direct lighting.

49

52. *Specular reflection is characteristic of highly polished or glassy surfaces. The light sources are reflected specularly in this vase by Julian Wolff.*

53. *Surfaces or objects surrounding the object being photographed can also be reflected specularly in the object. Note that the color of the material on which Helen Baskin's* Black Burnished Vessel *stands is reflected on the work itself.*

54. *Diffuse reflection is characteristic of textured surfaces. While the color of the materials used in this basket by Alice Wansor is uniform, diffuse reflection of the light causes slight differences in tone to appear in the photograph.*

55. *Direct lighting can result in specular reflections and "hot spots." Note the loss of detail caused by the specular reflection of the sun when this* Black Burnished Vessel *by Helen Baskin was photographed outdoors.*

56. Direct lighting can also cause an apparent increase in contrast between brightly lit and deeply shadowed areas of the subject, as illustrated in this photograph of *Torso* by Naomi Feinberg. (*Photo courtesy the artist.*)

57. *Direct lighting, whether from one or more light sources, can produce distracting shadows. However, whenever more than one light source is used, the problem is exaggerated. Here a basket by Alice Wansor has been lighted with two studio lights. Note the deep shadow in the center of the work* (left). *When only a single light is used, the shadow appears more normal* (bottom left).

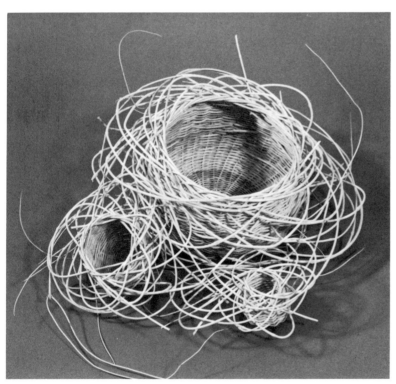

58. *Specular reflection of a diffuse light source, in this case light bounced off or reflected by a ceiling, appears on a glass paperweight* (right), *but the presence of such a reflection is sometimes difficult to ascertain. However, by interposing an object between the light source and the work being photographed, the reflection can be clearly seen* (below).

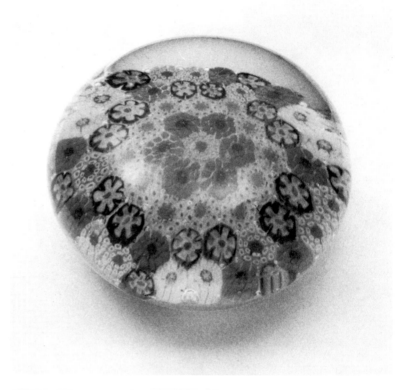

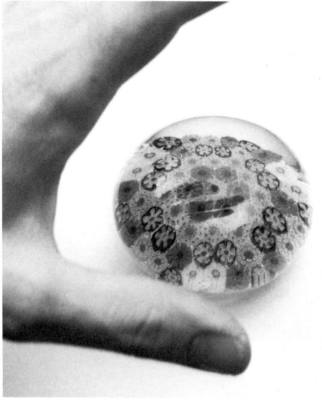

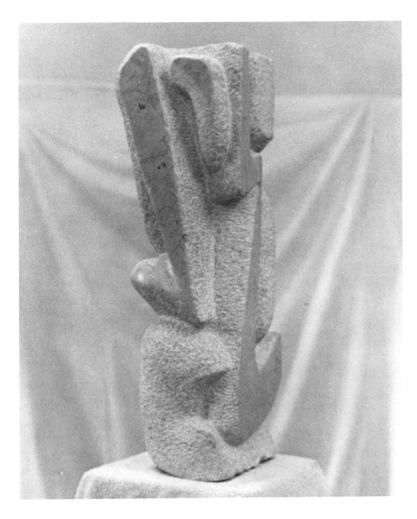

59. *Indirect or diffuse light can result in loss of image contrast, as can clearly be seen in this photograph of* While Gentle Things Were Said *by Naomi Feinberg (Photo courtesy the artist).*

ished or glassy works will be evident as a result of the large light sources used (Figure 58). Under diffused lighting, evenness of similar tones and colors in the work will be retained to a greater degree than with direct lighting, but overall contrast in the image will be reduced (Figure 59). Therefore, if the work is inherently low in contrast, you may wish to manipulate the light to add some contrast and visual interest to the final image. Also, textural qualities and shadowing, which are emphasized by direct light, will be minimized under diffuse light.

As you can see, careful and thoughtful selection and use of light sources can result in objectively accurate and subjectively attractive images of the works. Standard and unusual lighting problems and their solutions will be discussed in Chapter 7.

DIRECTION OF THE LIGHT

In describing the locations of light sources in relation to the subject being photographed, the following terms are used:

Front light: directed toward the subject from the position of the camera (Figure 60A).

Side light: directed toward the subject from the left or right side of the subject (Figure 60B, left and right).

Back light: directed toward the subject from behind the subject (Figure 60C).

60. *An object can be lighted from many directions for different effects:* (page 56) *(A) front light; (B) left side light;* (page 57) *(C) right side light; (D) back light;* (page 58) *(E) top light; and (F) bottom light.*

A

B

C

D

57

E

F

Top light: directed downward toward the subject from above (Figure 60D).

Bottom light: directed upward toward the subject from below (Figure 60E).

There are also two more terms:

Main light: The major light source, the source whose effect is most clearly evident, is called the "main light." The use of a single main light may leave some areas of the object in deep shadow where texture, detail, tone, and color are not visible.

Fill light. Supplementary light sources can be used to illuminate the shadowed areas. These secondary sources, usually lower in intensity or farther from the subject than the main light, are called "fill lights."

QUESTIONS AND ANSWERS

What is the best combination of light source and film?
The "best" combination is practical, affordable, and produces an acceptable photographic rendition of the work of art. In 35mm format, I use Kodachrome 25 and 64 with daylight and electronic flash, Kodachrome 40 with 3400K bulbs, and Ektachrome 50 and 160 with 3200K bulbs. Experience and personal preferences, results of tests on equipment, as well as the type of work to be photographed, all help determine which combination(s) work best with the camera, lenses, and lighting equipment to be used.

How long do conventional tungsten and tungsten-halogen bulbs last?
The following table shows the typical life expectancy for commonly available lamps:

BULB	LIFE (HOURS)
3400K 250 watts (no. 1 photoflood)	3
3400K 500 watts (no. 2 photoflood)	6
3200K 250 watts	20
3200K 500 watts	60
3200K, 3400K 250 watts, tungsten-halogen	200+

Is it necessary to discard bulbs that have reached the end of their "life"?
No. Such bulbs, if not unduly blackened with tungsten deposits, can still be used for black-and-white photography. If burned much beyond their rated life, subtle color shifts may appear in color slides. Keep track of how many hours each bulb is burned and write the amount on the paper protector in which the bulb was purchased. Replace the bulb with a new one when its rated life is reached; save the old bulb for black-and-white work.

4. FILM, FILM EXPOSURE, AND PRINTS

This chapter discusses the basic structure of film, how film is affected by light, how the images of a subject recorded on the film are produced, proper exposure of film, and image quality in transparencies and prints.

PHOTOGRAPHIC FILM

Photographic film, whether black-and-white or color, consists of an emulsion of gelatin and microscopic crystals of light-sensitive silver salts (called "halides") bonded to a clear support. When light strikes the film, some of the individual silver halide crystals are chemically changed. Intense light causes many crystals to change, but where no light strikes the film, no change occurs. Intermediate light intensities cause corresponding amounts of chemical change.

The image of the subject formed by the lens on the film is thus recorded. But at this point the image is latent—that is, invisible. To produce a visible film image, the film must be chemically processed to convert the light-struck silver halide crystals into visible metallic silver particles. During processing, the light-struck crystals are converted in direct proportion to the amount of light that struck them. Thus areas receiving the most exposure become dense with silver particles or grains, while areas receiving no light remain chemically unchanged. Various intermediate densities of silver grains are formed in areas of intermediate exposure.

After the exposed silver halides are developed, unexposed and undeveloped crystals must be removed from the emulsion. This prevents further chemical changes from occurring when the developed film is exposed to light. It also changes the overall opaque appearance of the film to reveal the images recorded. Again, this process is performed chemically.

NEGATIVE FILM

Completely processed negative film records a negative, tonally reversed image of the subject (Figure 61A). In other words, dark areas of the subject correspond to clear areas of the film, and light areas of the subject correspond to dark areas of the film. Through a process called "printing," this negative image is used to produce a positive image of the subject on paper coated with a similar silver-laden emulsion. Essentially the same method of exposure and development used to produce the negative is used to produce the positive print. And the tonal reversal that occurred between the subject and the film occurs again between the film negative and the positive print (Figure 61B).

In color negative films, in addition to the reversal of tones, colors are rendered as their complements. This is not immediately evident when examining color negatives

61. When a photograph is taken, the subject is recorded on negative film (left). After the film is processed, it yields a tonally reversed image of the subject—a positive print (above). This work—Canyon Wall Series II by Jan Wunderman—is shown in color on page 84.

since a special orange-colored "mask" is incorporated into the emulsion of the film, which hides some of the subtle colors present in the negative. The "mask" is necessary for proper color rendition of the subject both in the negative and in color prints made from the negative. Color negative films, unlike black-and-white negative films, contain no metallic silver after processing. During processing, a negative silver image is formed and color dyes are generated chemically in the three separate color layers that constitute the color emulsion. When the dyes have been formed, the silver image is no longer needed and it is removed through a bleaching process.

POSITIVE FILM
In addition to color and black-and-white negative films, positive films are available. The most commonly used positive films are color films, or "transparencies" (see Figure 62 in the color section of the book). Transparencies reproduce both the tones and colors of the original subject and are viewed by transmitted light rather than by the reflected light used to view positive prints. (In other words, light must pass through the transparency for it to be seen, rather than strike its surface, as it would a photograph.) The term "transparency" generally refers to all positive films. However, in popular usage, the term is used in reference to large positive film images, and smaller images, such as those obtained using 35mm film, are popularly called "slides."

Unlike color and black-and-white negative films, completely processed positive films record positive images of the subject directly on the film itself. In fact positive films are also called "reversal films" because, during processing, a negative image is formed and then reversed,

resulting in a final positive film image. Thus, the film image returned from the processor as a slide or transparency is actually the original film that had been exposed in the camera and processed. Like color negative films, color transparencies and slides contain no silver. The image seen is entirely composed of color dyes.

IMAGE QUALITY

There are five important factors that affect the quality of film images: film speed, grain, color sensitivity (in black-and-white films), color fidelity (in color films), and film exposure. While each of these factors affects image quality individually, the overall image quality depends on their combined effects. The selection of an appropriate black-and-white or color film and proper exposure can greatly improve the quality of the images obtained.

FILM SPEED

The sensitivity of a particular film emulsion to light is based on the size or sizes of silver halide crystals contained in the emulsion. Large silver halide crystals react more quickly to light than smaller silver halide crystals. Under identical lighting conditions, an emulsion containing primarily large-size silver halide crystals could be exposed to light for a significantly shorter time at a particular aperture than an emulsion containing primarily small-size silver halide crystals, yet each would yield equivalently exposed film images.

Film-speed ratings are an index measuring the comparative sensitivity or insensitivity of films to light. American Standards Association (ASA) numbers are one uniform film-speed rating system in general use in the United States. Other systems currently in use include the German Deutsche Industrie Norm (DIN) and the International Standards Organization (ISO). The film-speed rating numbers assigned to each film in these systems are printed on the film box and/or cassette for easy reference (Figure 63). A comparison of the systems follows:

63. *Film-speed ratings are printed on the film box* (top) *or film cassette* (above).

COMPARISON OF FILM-SPEED RATING SYSTEMS

ASA	DIN	ISO
6	9°	6/9°
12	12°	12/12°
25	15°	25/15°
50	18°	50/18°
100	21°	100/21°
125	22°	125/22°
160	23°	160/23°
200	24°	200/24°
320	26°	320/26°
400	27°	400/27°
800	30°	800/30°
1600	33°	1600/33°

Films with large silver halide crystals are relatively sensitive to light. They have ASA numbers between 160

64. The granular appearance of film and print images is due to the presence of silver particles during film processing.

and 800 (or more) and are called "fast" or "high-speed" films. Films with moderate-size silver halide crystals have relatively moderate sensitivity to light. They have ASA numbers between 50 and 160 and are called "moderate" or "medium" speed films. Films with small silver halide crystals are relatively insensitive to light. They have ASA numbers less than 50 and are called "slow" films.

The mathematical relationship between different ASA numbers can be illustrated as follows: A doubling of ASA numbers indicates a doubling of film speed or sensitivity, while halving of ASA numbers indicates a halving of film speed or sensitivity. Thus, ASA 64 film is twice as "fast" or sensitive as ASA 32 film. It would require exactly one-half as much exposure to yield an equivalent image on the film. ASA 200 film is only half as "fast" or sensitive as ASA 400 film, and would require exactly twice as much exposure to yield an equivalent image on the film.

FILM GRAIN

As already noted, when film is developed, individual silver halide crystals are converted into silver. During the process, small silver particles clump together to form larger grains of silver. When the processed film is greatly enlarged or examined under a microscope, the pattern of developed silver grains (or color dyes in color films) is evident (Figure 64). The size of the silver halide crystals present in unexposed and undeveloped film has a direct bearing on the ultimate grain size in processed film. The chemicals and technique used to develop the film will also affect grain size.

Fast films contain large silver halide crystals and produce the most noticeable grain. Slow films are primarily composed of extremely small crystals and produce the least noticeable grain. Moderate films produce moderately fine grain noticeable only in large enlargements of the negative.

Grain size is also increased when overactive developers and/or extended developing times are used. Overexposure of the film will also cause increased graininess. However, with proper exposure and development of the film, graininess will be minimized.

COLOR SENSITIVITY OF BLACK-AND-WHITE FILMS

There are two major types of black-and-white film: orthochromatic and panchromatic. Orthochromatic emulsions are insensitive to red light and are not commonly used by photographers of art. Panchromatic emulsions are sensitive to all colors of visible light, but they are not *equally* sensitive to all colors.

Panchromatic films tend to be blue-sensitive, a characteristic that can be somewhat corrected by using a yellow filter. Under tungsten illumination, a Wratten No. 11 yellow-green filter should be used to more closely approximate the visual brightness of colors. Under daylight conditions, a Wratten No. 8 yellow filter should be used. Additional information on the use and application of filters can be found later in this chapter.

COLOR FIDELITY OF COLOR FILMS

Color positive and color negative films and color positive print papers produce color using magenta, yellow, and cyan dyes. Each color is produced in a separate layer of the film's or the paper's emulsion. Colors such as red, green, and blue appear in prints and transparencies of the film or paper. They do not combine chemically but, because they are transparent, they combine visually to form the colors of the subject.

No color film or paper reproduces all colors with absolute fidelity. So when slides of the same subject are made on different brands or types of color film, for example, while each will approximate the colors of the original subject, when they are compared to one another, variations in specific colors will be evident. To determine the color fidelity of different films, compare equivalent film images with one another as well as with the original subject. Gross color distortions will be evident when you compare the image with the subject, while smaller color distortions will be evident in comparing one type of film with another.

By far the most important test of color film is its ability to record colors such as red, green, and shades of gray. The thorough testing procedures detailed in Chapter 5 will allow you to critically evaluate the ability of specific films to accurately reproduce color.

FILM EXPOSURE

As you have already learned, exposing film is the first step in the process of producing positive or negative film images. That is, in order for subsequent chemical development to produce acceptable images, the film must first have been "properly" exposed in the camera. However, what constitutes "proper" film exposure has been and continues to be the subject of countless books on pho-

tograpy. Since techniques of film exposure and development vary widely among photographers and are dependent on subject matter, lighting conditions, and other factors, as well as the intent and personal preferences of the photographer, I will not review the techniques of other photographers here. However, those interested in processing their own film and working on their own exposure and development techniques will find several useful books on these subjects listed in the Bibliography.

For our purposes, accurate or "proper" film exposure is that which yields informative photographic reproductions of the subject. Color, gradations of color and tone, and detail should be accurately recorded on the film. To achieve accurate film exposure, the level of illumination present must be determined accurately, and an appropriate combination of lens aperture and shutter speed must be selected in accordance with the speed or sensitivity of the film.

THE EXPOSURE METER

The modern exposure meter (Figure 65) is a light-sensitive, photoelectric device used to measure illumination levels and to calculate exposure settings. A typical exposure meter consists of a photocell, a meter, a calculator dial, and a battery. The photocell generates a very small amount of electricity when it is struck by light; the amount of electricity generated depends on the amount of light striking the photocell. The battery provides additional electricity to cause the meter to deflect from its resting position in proportion to the amount of electricity produced by the photocell. A scale on the meter indicates values for specific levels of illumination. These are then transferred to the calculator dial, which in turn indicates appropriate combinations of lens apertures and shutter speeds based on the light level measured. Of the various types of exposure meters available, the two principal types are incident meters and reflectance meters.

INCIDENT METERS. Incident meters measure the intensity of light falling on the subject (Figure 66). A translucent dome at the front of the meter diffuses the light produced by all light sources used to illuminate the subject. Direct light, which might damage the photocell or meter, does not strike the photocell—the total amount of light falling on the subject is measured through the diffusing dome. Incident meters are only available as hand-held units.

A typical incident meter is used as follows (Figure 67): (1) The ASA dial on the meter is adjusted to the ASA number of the film in use. (2) The meter is switched on and is aimed toward the camera from the position of the subject. (3) The meter responds to the light emitted by the light source(s), and the exposure calculator dial is adjusted to correspond to the appropriate value indicated by the meter.

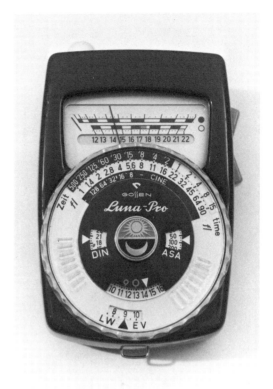

65. *This modern exposure meter can be used either as an incident or reflectance meter.*

66. *When light strikes the diffusing, translucent dome on the incident exposure meter, the level of illumination directed toward the object is measured.*

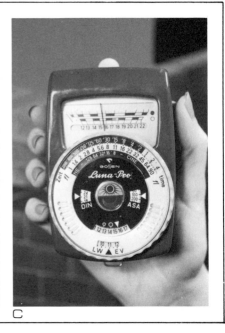

A B C

67. *To measure incident light, (A) the ASA dial on the meter is adjusted to the ASA number of the film in use (ASA 125). (B) The meter is then switched on and aimed toward the camera from the position of the subject. (C) The meter responds to the light emitted by the light source(s), and the exposure calculator dial is adjusted to correspond to the appropriate value indicated by the meter.*

REFLECTANCE METERS. Reflectance meters measure the intensity of light reflected by the subject (Figure 68). A hole in the front of the meter provides access to the photocell within, but a lens covers the hole and limits the direction of light to a specific angle of view. The angle of view varies among different kinds of meters, and some brands have adjustable angles of view. Reflectance meters are available as hand-held units and are built into many camera bodies. Of course, with built-in camera meters that measure light levels through the lens, the angle of view changes with the focal length and angle of view of the lens.

A typical reflectance meter is used as follows (Figure 69): (1) The ASA dial on the meter is adjusted to the ASA number of the film in use. (2) The meter is switched on and is aimed toward the subject. (3) The meter responds to the light reflected by the subject, and the exposure calculator dial is adjusted to correspond to the appropriate value indicated by the meter.

USING LIGHT METERS

With both types of meters, numerous combinations of lens apertures and shutter speeds are possible (Figure 70), each yielding equivalent film exposure. A suitable combination, based on the subject itself and the depth of field desired, is selected and the exposure controls on the camera are then adjusted accordingly.

Incident meters measure light falling on the subject, which is precisely the type of measurement needed when photographing works of art. This measurement is not dependent upon the reflectivity of the subject but upon the intensity of the light produced by the light sources.

Reflectance meters measure light reflected by the subject, which is a less desirable and less reliable type of measurement since it is totally dependent upon the reflectivity of the subject. Thus, under identical light

68. *Light reflected by the subject enters the reflectance exposure meter through a hole. Behind this hole is the photocell, which measures the intensity of the light.*

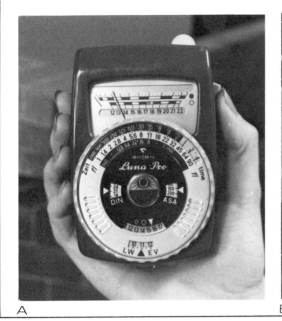

A

B

conditions, subjects with different degrees of reflectivity (for example, black marble and white marble) will produce different reflectance meter responses. Since the level of illumination is actually the same for each, an incident meter would have indicated identical exposure measurements for such subjects.

Reflectance meters are adjusted by their manufacturers to measure all light levels as if the light was reflected by "average" subjects containing a mix of dark-to-light tones. Such meters respond to dark-colored subjects as if they were "average" subjects in dim light and to light-colored subjects as if they were "average" subjects in bright light.

Reflectance meters indicate combinations of shutter speeds and lens apertures based on their calibration for an "average" subject. Thus, under identical light, the meter indicates that more film exposure is needed when photographing dark subjects and less film exposure is needed when photographing light subjects. Consequently, when using a reflectance meter alone to determine exposures, images of dark-colored subjects will appear lighter and light-colored subjects will appear darker than they actually are due to increased and decreased exposure, respectively. In an extreme example, individual images of a black panel and a white panel photographed under identical lighting will appear to be two images of one medium *gray* panel (Figure 71). Obviously, then, the reflectance meter cannot be used alone to measure exposures reliably because measurements for works that do not fall within the "average" range of subject tone for which the meter is calibrated are generally erroneous.

Is it necessary, then, to purchase an incident exposure meter in order to calculate exposures accurately? The answer is "no." You can use a reflectance meter to determine the level of illumination falling on the subject

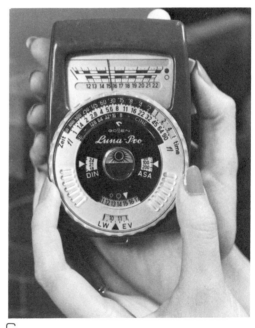

C

69. To operate the meter in measuring reflective light, (A) the ASA dial on the meter is adjusted to the ASA number of the film in use (here, ASA 125). (B) The meter is then switched on and aimed at the subject. (C) The meter responds to the light reflected by the subject, and the exposure calculator dial is adjusted to correspond to the appropriate value indicated by the meter.

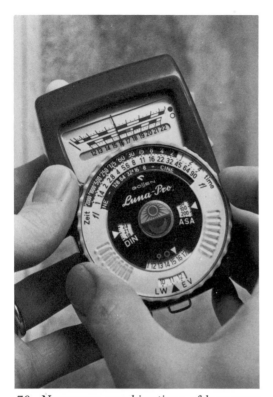

70. *Numerous combinations of lens apertures and shutter speeds can be used equivalently. The meter indicates which combinations will yield equivalent exposures of the film. The photographer then selects the aperture and shutter speed to be used and adjusts the camera's exposure controls accordingly.*

71 *(right). Under identical lighting conditions, film exposures based on reflectance meter readings of a black object and a white object will appear to be two exposures of one medium gray subject.*

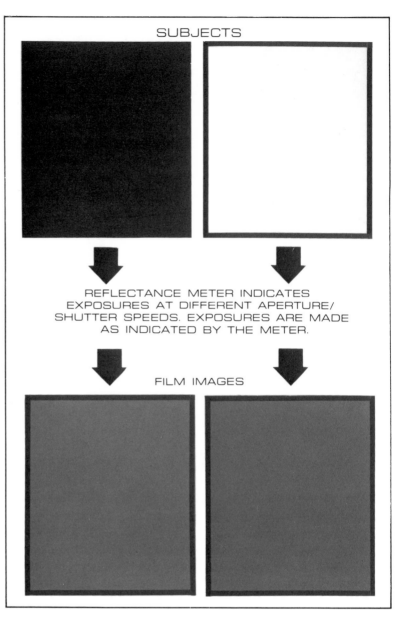

SUBJECTS

REFLECTANCE METER INDICATES EXPOSURES AT DIFFERENT APERTURE/ SHUTTER SPEEDS. EXPOSURES ARE MADE AS INDICATED BY THE METER.

FILM IMAGES

by positioning an "average" subject in place of the subject being photographed and measuring the light reflected from this "average" subject. You then adjust the lens aperture and shutter speed in accordance with this reading, and replace the "average" subject with the actual subject to be photographed. Then, without changing the exposure settings previously determined, you take the photograph.

THE NEUTRAL GRAY TEST CARD

The reflectance meter measures the overall reflectivity of the subject without regard for the distribution of individual tones. Thus, an "average" subject could consist either of a range of black, white, and gray tones, or of a single gray tone—as long as their reflectivity is the same. By experimenting, you could determine a suitable combination of gray tones or a single gray tone that represents the reflectivity of an "average" subject, but this is not really necessary because a representative "average" subject already exists. It is called an *18-percent reflectance neutral gray test card* (Figure 72).

Exposure measurements are determined by aiming the meter at the gray card while the card is held in close proximity to the subject. The meter is held so that no shadows are cast on the card by the meter and only light reflected by the gray card is measured (Figure 73). Measuring the light reflected by the gray card provides the required exposure information independent of the actual reflectivity of the subject. Meter readings are identical under identical lighting. In effect, the reflectance meter has been transformed into an incident meter by using the gray card in place of the subject while exposure settings are determined.

As previously indicated, the gray card must be used close to the subject to obtain accurate meter readings. But for the reading to be accurate, only light reflected by the gray card must strike the meter. This presents problems when using a camera's built-in reflectance meter since it is awkward to hold both the gray card and the camera while attempting to adjust the lens aperture or shutter speed. Also, the camera should be mounted on a tripod while taking photographs, and it is inconvenient to remove it from the tripod to establish or confirm your exposure settings. Therefore, I would highly recommend that you obtain a hand-held reflectance or incident exposure meter, if at all possible. The expense of the meter will be fully justified in the long run.

FILM DATA SHEETS

As a general rule, film manufacturers provide customers with a compendium of useful information with each purchase of their film. It is called a "film data sheet" (Figure 74) and is usually placed in the film box. In addition to providing the ASA of the film, the sheet may also give basic exposure information for using the film under a wide variety of lighting conditions. This information is most useful to the amateur photographer, whose lighting conditions vary widely.

As you know by now, exposure must be calculated exactly when photographing art under controlled lighting conditions. Because of this, it is best not to rely on the data sheet alone to determine exposure, and in later chapters you will see how film exposures may be fine-tuned to your specific requirements.

One type of film data sheet that is absolutely essential to proper film exposure is the one provided with sheet film used with large-format cameras. Since each emulsion sheet film varies slightly in its response to exposures of different lengths of time and in its effective ASA rating, a typical data sheet (Figure 75) indicates additional factors that must be considered under these specific conditions. This information will save you valuable time and materials that would otherwise be spent determining how one emulsion varies from other emulsions.

Amateur film emulsions also vary slightly from batch to batch. However, the variations are extremely subtle

72. An 18-percent reflectance neutral gray test card represents an average subject.

73. To obtain accurate reflectance meter measurements you must hold the meter close enough to the card so that only light reflected by the card is measured, while making sure that no shadows are cast on the card.

KODAK EKTACHROME 160 Film (Tungsten)

For Color Slides

135 MAGAZINES

This high-speed color-slide film is balanced for 3200 K tungsten lamps. It has improved color rendition, resulting in higher-quality slides. The high speed makes it ideal for taking pictures under existing tungsten light in a variety of situations. By obtaining special processing, you can expose this film at ASA 320. See the "Processing" section.

With most types of fluorescent lighting and carbon-arc lamps, use KODAK EKTACHROME 200 Film (Daylight).

Handling and Storage: Load and unload your camera in subdued light. Have the film processed promptly after exposure. Store film and slides in a cool, dry place.

EXPOSURE

Type of Light	Film Speed	Filter
TUNGSTEN 3200 K	ASA 160	None
PHOTOLAMPS 3400 K	ASA 125	No. 81A
DAYLIGHT	ASA 100	No. 85B

Note: Exposures longer than 1/8 second may require filtration and exposure compensation. For information on this subject, write to Eastman Kodak Company, Photo Information, Department 841C, Rochester, N.Y. 14650.

Set your exposure meter at the proper speed given above, and expose as indicated by the meter. However, if your camera has a built-in exposure meter that makes the reading through a filter used over the lens, see your camera manual for instructions on exposure with filters. The table below is for existing light without a filter. These settings are **guides**; for more certainty, bracket your exposures by one stop on each side of the suggested exposure.

Existing-Light Exposure Table (at ASA 160)		
Picture Subject	Shutter Speed (second)	Lens Opening
In Homes at Night—Areas with Bright Light	1/30	f/2
Areas with Average Light	1/15*	f/2
Candlelighted Close-ups	1/8*	f/2
Indoor, Outdoor Christmas Lighting at Night	1*	f/5.6
Brightly Lighted Downtown Street Scenes at Night	1/30	f/2.8
Brightly Lighted Theatre Districts—Las Vegas or Times Square	1/30	f/4
Neon Signs, Other Lighted Signs	1/60	f/4
Store Windows at Night	1/30	f/4
Floodlighted Buildings, Fountains, Monuments	1/2*	f/4
Distant View of City Skyline at Night	1*	f/2*
Fairs, Amusement Parks	1/30	f/2
Aerial Fireworks Displays—Keep camera shutter open for several bursts	BULB or TIME*	f/11
Night Football, Baseball, Racetracks†	1/60	f/2.8
Basketball, Hockey, Bowling	1/60	f/2
Boxing, Wrestling	1/125	f/2
Stage Shows—Average Lighting	1/30	f/2.8
Bright Lighting	1/60	f/4
Circuses—Floodlighted Acts	1/30	f/2.8
Ice Shows—Floodlighted	1/60	f/2.8
School—Stage and Auditorium	1/15*	f/2
Swimming Pool—Indoors, Tungsten Lights Above Water	1/30	f/2
Church Interiors—Tungsten Lights	1/15*	f/2

*Use a tripod or other firm camera support. †When lighting at these events is provided by mercury-vapor lamps, you'll get better results by using daylight-type film.

Basic Daylight Exposure
In bright sunlight, with a No. 85B filter over the camera lens, use 1/125 second at f/16.

74. *Film data sheets for 35mm roll film provide useful information to the amateur photographer.*

KODAK EKTACHROME Professional Film 6118 (Tungsten)

ENGLISH

- A color reversal film for producing color transparencies using Process E-6.
- Color-balanced for exposure to tungsten (3200 K) lamp with a 5-second exposure time.
- Intended exposure range is 1/10 second to 100 seconds.
- The EKTACHROME transparencies are suitable for direct viewing, or printing by photomechanical methods or by the photographic methods described in Kodak Publication No. E-77, *KODAK Color Films.*
- The slides are balanced for direct viewing using the standard 5000 K source adopted by the American National Standards Institute.

Important: Supplementary information for the specific emulsion number of film in this package is given at the bottom of this page. Effective speeds given for ½- and 30-second exposures include the exposure increase required by the suggested reciprocity correction filters.

Trial Exposure: For the best color balance with your equipment and process, minor adjustments in speed or color balance may be necessary, even at a 5-second exposure time. Use trial exposures to determine these adjustments.

Light Sources:

Light Source	Exposure Adjustment
Tungsten (3200 K)	See supplementary information below.
Photolamp (3400 K)	KODAK Light Balancing Filter No. 81A with 1/3-stop more exposure.*
Daylight	KODAK WRATTEN Gelatin Filter No. 85B with 2/3-stop more exposure.*

*These adjustments are in addition to the exposure conditions given below.

Supplementary Information		
EMULSION NUMBER	**EFFECTIVE SPEED** at 5-second exposure.	
6118-939	**EI 32**	

The following reciprocity information, determined at the time of manufacture, applies specifically to film bearing the emulsion number given. Use this information as a guide for making test exposures when exposure and color-balance requirements are critical.

EXPOSURE TIME	EFFECTIVE SPEED	RECIPROCITY CORRECTING FILTER(S)
½ sec	EI 40	CC05G
30 sec	EI 16	CC05B

©Eastman Kodak Company, 1978

75. *Film data sheets for 4×5" sheet film provide essential exposure information, such as film-speed ratings and color-correction filtration for exposures of different lengths of time. The data are based on tests performed by the manufacturer. Since these factors may vary from one film emulsion to another, such information is invaluable.*

and are usually undetectable. Nevertheless, as a general rule, specific films should be tested to determine their suitability for photographing works of art (see tests in Chapter 5.) Therefore, the emulsion number of the film, printed on the side of the film box (Figure 76), should be noted for future reference as part of the test. If color and detail rendition prove satisfactory, you can then purchase an additional supply of film with the same emulsion number. Films with the same emulsion number will have the same characteristics as long as the film is properly stored until used.

76. *The emulsion number of the film is plainly printed or embossed on the film box.*

FILM STORAGE

Unexposed film should always be stored in a cool, dry place away from any source of heat or direct light (which produces heat). Ideally, film should be stored in a refrigerator or freezer. When left in its original sealed container and frozen film will remain relatively unchanged for long periods of time. To use the frozen film, move it from the freezer to the refrigerator for several hours and then into the room, where it must be allowed sufficient time to reach room temperature before opening. If the film is opened too soon, moisture in the air will condense on it, which can damage the emulsion. Refrigerator storage alone is best when the film will be used in a relatively short time.

77. *Materials for mounting slides under glass are available from numerous manufacturers.*

Exposed film should not be stored but should be processed as soon as possible because the image recorded on the film is not a permanent image, but a latent one. This unstable, latent image will change in time, causing loss of shadow detail and color shifts in color film.

Processed film should be stored in a cool, dry place where heat and strong light will not reach it. Slides may be glass-mounted, if desired, using anti-Newton ring glass (Figure 77). The glass will protect the film from fingerprints, scratches, and soiling. But before embarking on an ambitious slide-mounting project, be sure the glass-mounted slides will fit your projector. Another word of caution: never mail glass-mounted slides because the glass may break in transit and damage or scratch the film.

Negatives should be stored in acid-free negative sleeves and placed where they will not be handled excessively. There are many different types of negative sleeves and storage systems. Select the materials and system that will allow you easy access to the negatives you require without undue handling of the other negatives. Remember, the potential for damage to all film images increases with handling.

PHOTOGRAPHIC PRINTS

Black-and-white and color prints are positive images produced on appropriate print papers from black-and-white and color negatives and/or color transparencies.

Print papers consist of an emulsion of suspended silver particles and a support to which the emulsion is bonded.

The composition of the emulsion can be varied in black-and-white papers to match the requirements of specific contrast in negatives so that a print with the desired range of gray tones can be produced from negatives with too little or too much contrast.

The composition of color print emulsions can be varied so that negatives and transparencies can both be used to produce positive prints. Like color film, color printing papers are produced in batches that vary slightly in their response to light.

The process of producing color prints, while not overly complex to explain, however, is beyond the scope of this book. Likewise, this is not a detailed treatment of the entire range of black-and-white materials currently available, nor of the processing of black-and-white prints. Instead, this section will familiarize you with the terms used to describe photographic prints and provide direction to those who require prints but cannot produce them themselves. Obviously, those who can already produce prints in their own darkroom will find much of this information to be a repetition of what they already know. (Note: Always remember that the term "prints" refers to photographs rather than to graphic works.)

BLACK-AND-WHITE PRINTS
The most important characteristics of black-and-white prints are: image tone, base color, surface luster, paper weight, and contrast.

IMAGE TONE. "Image tone" is the overall coloration in black and gray areas of the print. This tone varies from warm (brownish) to neutral gray to cold (bluish). While image tone may not be immediately evident when looking at a single print or at groups of prints made on the same paper and processed in the same chemicals, image tone differences become evident when prints made on different papers and/or processed in different chemicals are compared with one another.

BASE COLOR. "Base color" is the color of the printing paper beneath the emulsion. It is also the color that will be seen in white areas of the print. This varies from cream to off-white to white, but the most common base colors are white and off-white. Cream-colored papers are not generally used when reproducing works of art.

SURFACE LUSTER. "Surface luster" is the texture of the surface of the print emulsion. Commonly available surfaces, as they are called, include silk, matte, and glossy. Glossy, highly reflective surfaces permit a long tonal range to be viewed because light striking the surface of the print is not scattered or diffused. Matte and silk surfaces interfere, to some extent, with the visual appreciation of the information contained in the print.

PAPER WEIGHT. "Paper weight" is a measure of the substance of the paper support beneath the emulsion. Standard weights for conventional papers are single-

weight (SW) and double-weight (DW). Resin-coated (RC) papers are generally available in a standard medium-weight (MW) substance. These letter codes are commonly used to designate the substance and type of paper.

CONTRAST. "Contrast" is a measure of the ability of a specific paper to reproduce black, white, and a variety of gray tones from high-, medium-, and low-contrast negatives. Papers are graded to indicate their characteristic contrast so that a paper can be easily matched to a specific negative. Papers are graded "hard," "medium," and "soft," and are to be used respectively, with low-, medium-, and high-contrast negatives. Numeric designations are also used to indicate paper contrast. A typical grading system uses the numbers one to five to indicate the degree of "softness' or "hardness" for each of five papers. The lower the number, the softer the paper; the higher the number, the harder the paper. Papers with "normal" contrast, which would be used with negatives of "normal" or "medium" contrast, generally are grades 2 or 3. However, the contrast of specific papers varies, along with the grading systems, among manufacturers. The accompanying photographs (Figure 78) illustrate how a negative of normal contrast reproduces on papers of different grades.

Variable contrast papers are also available that, through a series of contrast filters, allow you to control the contrast of the image produced from a specific negative. This feature is particularly useful when negative contrast falls within a narrow range. The contrast in variable contrast paper is not as wide as that available with a full range of graded papers, but one particular advantage of using variable contrast paper is that you do not need to have a stock of papers of each grade.

By following the recommendations for exposing negative film contained throughout this book, your negatives will naturally fall within such a narrow range of contrast. High- and low-contrast papers are generally required only under the most unusual circumstances, such as when you have unintentionally over- or under-exposed the negative.

It is important, however, to understand the difference between a print that lacks detail because of inadequate or improper printing and one that lacks detail because the negative from which it was made lacks detail. No print can reproduce more information that is contained in the negative, but it can reproduce less detail through careless printing. Film will record far more contrast in subjects that printing papers are able to reproduce. Details will be lost in highlight and/or shadow areas in prints made from negatives containing excessive contrast. But careful control of lighting contrast will allow details to be rendered throughout the image in both the negative and the print. The techniques of proper lighting, including lighting contrast, are explained in Chapter 6.

A

B

C

D

E

78. Here are the results of printing a negative with normal
contrast (a range of light to dark tones) on photographic papers
with different grades of contrast: (A) Grade 1 paper produces a
low-contrast, "flat" print from a normal negative. It is best
suited to reducing a high-contrast negative to a more normal
range of tones. (B) Grade 2 paper produces a full range of tones
from a normal negative. It is best suited to accurate rendition of
tones in a normal negative. (C) Grade 3 paper produces a full
range of tones from a normal negative but evidences an increase
in tonal differentiation between the darkest and lightest areas of
the print. It can be used to add a slight bit of contrast to prints
from a normal negative or one with slightly less contrast than
desired. (D) Grade 4 paper produces fewer gray middle tones
from a normal negative than grades 2 or 3, with increased
"space" between each of the gray tones actually rendered. It is
best suited to negatives of low contrast. (E) Grade 5 paper
produces the starkest black-and-white image, with the fewest
gray middle tones, from a negative of normal contrast. It is best
suited to negatives of very low contrast, but even then it may not
provide a full range of tones in the final print.

79. Here is a selection useful books on color slides and color prints.

COLOR PRINTS

Color prints can be produced instantly, using Kodak or Polaroid cameras and instant print films, or they can be produced from color negatives or color transparencies.

Instant prints contain a negative recording material and dyes sandwiched into a thin package. When the photograph is taken, the image is recorded negatively and the print is ejected from the camera. The color dyes then travel upward through the negative and appear at the surfaces of the print. The resultant positive image closely resembles the original subject. Of course, the negative remains within the print itself and cannot be used to produce additional prints of the subject. When additional photographs are required, additional original prints must be made or the original print must be copied the required number of times.

Color negatives and transparencies can be projected onto color printing paper, which is then processed to obtain positive images. While the procedure is similar to that used to produce black-and-white prints, the resultant image is a color reproduction of the original subject. Consequently, it is important that the colors of the original be accurately reproduced.

Print colors are controlled by the color of the light to which the print paper is exposed. Color printing filters are used in the light path of the enlarger projecting the negative or transparency in order to adjust color reproduction in the print. Experimentation, while expensive and time consuming, is necessary to achieve a print with acceptable color reproduction. Other factors that affect color reproduction include: balancing of light source and film; film exposure; the type of color film used; the processing of the print; and, perhaps most important, the ability of the color dyes in the negative/transparency and the print material to acceptably reproduce the color of the original subject.

The most important color print characteristics you should be familiar with are: color balance, surface luster, and contrast.

COLOR BALANCE. "Color balance" is the accurate rendition of color in the subject in prints made from negatives and transparencies. To compare prints to the original subject, which will reveal any imbalance in color, you must view both under identical lighting. Be prepared to identify: (1) any overall shifts in color and (2) the color fidelity of individual colors. Overall color shifts generally indicate that a change is necessary in the filtration of the light used to produce the print. If the overall color balance is adequate but one or two colors are reproduced inaccurately, you can safely assume that the color dyes in either the film or the print material cannot reproduce the color accurately. You will find color printing guides useful in helping you identify specific problems associated with color balance and color fidelity (Figure 79).

SURFACE LUSTER. In color prints as well as in black-

and-white prints, "surface luster" is the texture of the emulsion of the surface of the print. For color prints, only glossy surfaced paper is recommended. Matte and silk surfaces interfere with and detract from detail in the print.

CONTRAST. In color prints, "contrast" is a visual measure of the ability of the paper to record detail in the highlight and shadow (light and dark) areas of the negative or transparency. Color papers are not available in various grades of contrast. A negative or transparency that contains more contrast than the print is able to record will lack detail in those areas and will appear "contrasty." Conversely, a negative with little contrast will produce a print that lacks contrast and appears "flat." Negative contrast, therefore, must be carefully controlled to maintain highlight and shadow detail.

Transparencies, which are by their nature slightly more contrasty than the subjects recorded, will produce prints with even greater contrast because of the nature of the print materials used. Transparencies used to make prints must, therefore, have a very limited contrast range. The prints from such transparencies will restore the contrast that will make the photograph of the subject visually interesting. Of course, lighting for transparencies that are to be used for projection should be different from that for transparencies to be used for printing. They should be labeled accordingly to prevent confusion.

MACHINE-MADE PRINTS

Prints from negatives and transparencies can be produced by automated processing equipment that has been programmed by technicians. This equipment is designed to produce acceptable images most of the time. Since by far the largest group of consumers requiring machinemade prints are amateur photographers, the programmed instructions are designed to allow the processing equipment to produce acceptable prints of subjects amateur photographers are most likely to photograph—landscapes and portraits. Therefore unusual subjects—such as a red building, a moonlit landscape, or a pale pastel drawing on white paper—are printed as if they were family portraits or landscapes.

Automated color print processors measure the overall mix of colors in each negative they print. Adjustments are made in the filtration of the light used to project the negative onto the print paper to "add a little red" or "add a little blue" in order to adjust the mix of colors in the print to the level previously established as "average" by programming instructions. Negatives of subjects that are neither portraits nor landscapes, and therefore do not contain the "correct" mix of colors, are automatically adjusted to conform to the standard. This adjustment of color usually results in inaccurate renditions of works of art.

In addition to adjusting color, automatic processors also

adjust exposure automatically so that each print contains "normal" range of tonal values. Negatives that do not contain this "normal" range are adjusted so that the print does contain such a range. Thus, negatives of dark-colored and light-colored subjects are printed as if they were incorrectly exposed negatives of an "average" subject. The resultant prints will be tonally inaccurate. In fact, they will closely approximate the tonal gray of the 18-percent gray card.

CUSTOM-MADE PRINTS

Custom-made black-and-white and color prints are generally superior to machinemade prints in reproducing works of art. Custom-made prints are made by photographers or laboratory technicians one at a time.

To overcome the problems associated with reproducing works of art I would recommend that you provide the laboratory technician with a standard from which to work. After all, the technician will not know what the object in the negative actually looks like. This can be easily accomplished by photographing an 18-percent gray card at the beginning of each roll of film and at every point where lighting conditions change. The gray card should fill the film frame, if at all possible. Since the gray card represents an average subject both in tone and color balance, the technician can adjust the exposure of the paper based on exposure measurements determined using the gray card negative, and print adjacent negatives of the subject that have been photographed under identical lighting conditions. The net result is a properly exposed print containing the colors, tones, and contrast of the original subject.

Whether or not you intend to have custom prints made from negatives, it is always prudent to photograph a gray card at the beginning of each roll of film, where lighting conditions change, and, in the event the work will be reproduced in a brochure or elsewhere, beside the work itself. Then if you need prints at a later date, the information required by the printer will be there.

FILTERS

Filters both absorb and transmit light. Used in front of the lens, they alter the light reflected by the subject by adding or removing specific wavelengths.

Filters used in black-and-white photography are called "contrast filters" (Figure 80, also see color section). By absorbing some colors of light and transmitting others, contrast filters increase the contrast between the colors that would otherwise appear totally equivalent in black-and-white film and prints. The use of filters will be necessary where the essence of the works photographed depends on the appreciation of tonal differences that *were* apparent as variations of color visually, but that *do not* appear as variations of tones in black-and-white prints. Remember, black-and-white film does not record all colors equally well.

Contrast filters *subtract* some of the light reflected by the subject before it reaches the film. The effect a particular filter has upon tonal rendition in black-and-white depends on the colors it subtracts as well as on the color it transmits. The following table describes how filters affect color in the image as *printed* in black-and-white.

FILTER COLOR	SUBTRACTS	TRANSMITS	EFFECT IN PRINT
Red	Green & blue	Red	Green darker Blue darker Red lighter
Blue	Green & red	Blue	Green darker Blue lighter Red darker
Green	Red & blue	Green	Green lighter Blue darker Red darker
Yellow	Blue	Yellow	Blue darker Yellow lighter

Filters used in color photography are called either *color-compensating (CC)* filters or *light-balancing* filters. Color-compensating filters compensate for the decreased response of a particular film emulsion to specific colors based on the length of the exposure (see the discussion of film data sheets earlier in this chapter), or based on the general character of a particular emulsion.

Light-balancing filters adjust the color of the light source to match the color balance of the film in use. It is possible, although not recommended, to use tungsten balanced film with daylight illumination and an appropriate light-balancing filter on the lens. Consult the list of reference works in the Bibliography for more complete information on these two types of color filters and their uses.

QUESTIONS AND ANSWERS
Should I experiment with many different types of film to find one film that fits my needs?
To experiment with all the films currently available would be an expensive undertaking. For general use, a medium speed, ASA 125 black-and-white film and a fine-grain ASA 25 or ASA 64 color film can be used. Experiment with these. If they do not work successfully for you, try other films.

I took slides outdoors and the color is inaccurate. How can I determine the cause?
If you follow the testing procedure in the next chapter, you should be able to identify the source or sources of inaccurate color rendition. Remember that daylight conditions change as the sun's position in the sky changes. Other factors that affect the color of daylight, such as smog, pollution, high clouds, and overcast conditions, will also affect color rendition.

If the results I obtain with a custom laboratory are unacceptable, should I set up my own darkroom?
A home or studio darkroom is good only if you have enough time or money to spend working outside your primary field of interest. It makes more sense to develop a working relationship with local photographers, gradually allowing them more freedom to make decisions as their knowledge of your needs develops.

How do I use a gray card with an "automatic exposure" camera? With the meter on continually, I can't adjust the exposure setting for a specific meter reading. The camera makes all the exposure decisions for me. Auto-exposure systems are extremely useful for some kinds of photography, but they cannot be used successfully when photographing works of art unless you can override or switch off the automatic feature and adjust the exposure settings manually. Otherwise, the reflectance meter within the camera will indicate different exposure settings for each subject, and you won't be able to control the actual exposure of the film.

Is "outdated" film still useful?
It depends on what "outdated" means. If it was just purchased from a photography store as outdated and the date on the outside of the film box is recent, the film can probably be used without fear of gross color inaccuracy. If the film was purchased when fresh and has been sitting on a shelf over a radiator for two years, it is also outdated and would probably render colors poorly. If it was purchased when fresh and was then frozen, the date on the film box is relatively meaningless, since that date is based on shelf life in a retail store.

When film is produced, it is "green" and must "ripen" a little, like fruits and vegetables, before it can be used. Once aged, the emulsion remains relatively stable for some time. The date printed on the outside of the film box as the expiration date is simply a guide to the age of the film. It does not mean that once that date is passed the film is no longer useful. You must exercise good judgement in purchasing outdated film. Use it and have it processed quickly. If the results are acceptable, purchase as much as you can and freeze it. (You're likely to get a good price on outdated film, too.)

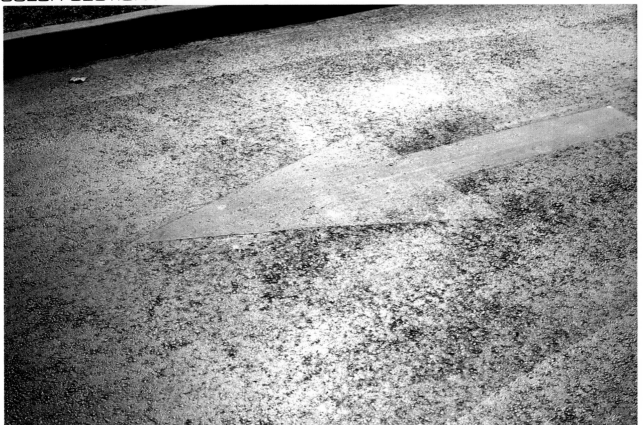

A

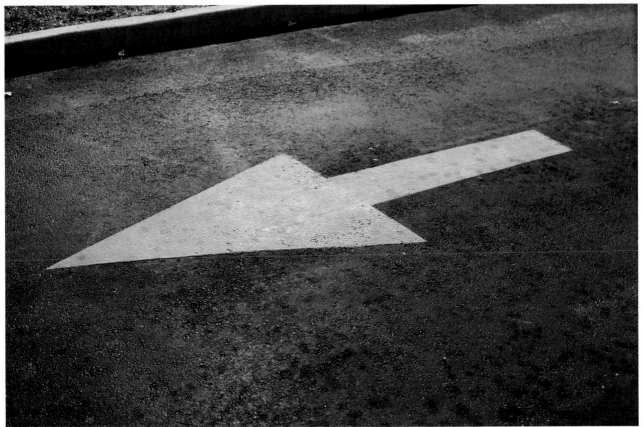

B

*41. In color photography, as in black and white (see page 42),
the polarizer offers may advantages. (A) When light reflected off
a surface obscures its texture and detail, (B) a polarizer will
eliminate such undesirable reflection.*

C

41. (C) because of the scattering of light in the atmosphere, especially near the horizon, a normal blue sky may appear washed out.

*41. (D) A polarizer "organizes" the light rays and allows the
true color of the sky to be recorded without changing the colors
in the rest of the photograph.*

D

62. Here are examples of a typical 35mm slide (top) *and 4 × 5" transparency* (above).

80. In black-and-white film, contrast filters are used to enhance and express the various colors—now seen as tones of black, white, and gray. You can determine which filters work best with various colors through experimentation. (A) To illustrate the effect of filters on colors in black-and-white photographs, various colored stamps have been photographed in color (Kodachrome 40, 3400K) above. On the following page, these same stamps are shown in black and white, first without filtration, then with various contrast filters. Note the effect of each filter, not only on the color it is designed to enhance, but also on that color's complement.

A

B

C

D

E

80 (continued). (B) no filter; (C) red filter; (D) green filter; (E) blue filter.

99. *Exposure information for 4 × 5" transparencies should appear in the film itself. To do this, write the exposure and emulsion numbers of the film on a sheet of paper and attach it to the test panel before you expose the film. Don't forget to change the exposure number for each photograph of the sequence.*

100. A completed series of nine 35mm slide exposures are shown above. Exposure time—in this case, ¼ second—was kept constant while the size of the apertures was varied: (A) f/32; (B) f/32–22; (C) f/22; (D) f/22–16; (E) f/16; (F) f/16–11; (G) f/11, (H) f/11–8; (I) f/8. You will find a similar series involving 4 × 5″ transparency exposures on page 129.

Part II.
Photographic Technique

Once you are familiar with your equipment, the proce-
dures and techniques used in photographing works of art
are easily learned. So to develop good technique, you
must begin by thoroughly examining and evaluating
your equipment, materials, and ability as a photographer
under controlled conditions. This preliminary step is
often overlooked by artists or photographers who believe
that, simply because they own an automatic camera, it is
a simple matter to take a picture of a work. But this is
not true. The detailed, step-by-step testing and evalua-
tion procedure in Chapter 5 is a necessary adjunct to the
selection of equipment discussed in earlier chapters.

In Chapter 6, you will learn specific basic techniques
for photographing two- and three-dimensional works of
art. While all two-dimensional objects are structurally
similar, their many variations may require subtle modifi-
cations of the basic photographic technique. Similarly,
while all three-dimensional objects share the characteris-
tic of "volume," they can vary enormously in every other
conceivable characteristic. Consequently, variations in
basic technique are also required when photographing
three-dimensional objects.

The nature of these variations is described in Chapter
7, "Problems and Solutions." This chapter will familiarize
you with methods of approaching and solving typical
problems encountered when photographing works of art.

5. EQUIPMENT TESTING AND EVALUATION

There are four reasons for testing your equipment. (1) To examine and evaluate your equipment under actual working conditions. (2) To determine the suitability of specific films for photographing art. (3) To assess your ability as a photographer under controlled conditions. (4) To gain experience in identifying and correcting problems. In this chapter, detailed instructions and illustrations accompany each step of the procedure. Follow these instructions exactly; deviations from the procedure will only result in inaccurate and therefore meaningless results. Once the procedure has been completed, you can evaluate the results, but if the procedure has been altered it will be extremely difficult to determine the cause of any defects. Remember, this procedure is designed to highlight problems.

When you are finished, you must interpret the results of the testing critically for it to be of value. In particular, you will look for lens distortion, image quality, and viewfinder accuracy. Although this book provides some guidance, your analysis will be primarily subjective.

Whenever your working conditions, film, and/or equipment are changed, you must repeat this testing procedure.

I strongly recommend that you begin testing your equipment by reading through the entire testing procedure to become familiar with the required equipment and the procedure itself. Then assemble your materials in a 10×12 foot (3×3.5m) or larger work area and begin. If you do not know precisely where you will or should be working, read the first section of Chapter 6, which discusses work areas, before performing the tests.

EQUIPMENT AND MATERIALS REQUIRED

You will need the following equipment to perform the tests:

Camera: 35mm SLR or 4×5″ view camera.

Lenses: All lenses that will be used subsequently for photographing objects.

Exposure Meter: Reflectance type, hand-held, with fresh batteries.

Light Source (select one): (1) Daylight (full sunlight or completely overcast). (2) Tungsten: two 250-watt 3200K or 3400K bulbs, two 10″ (25cm) reflectors, two light-stand mounting adapters and lamp·sockets, two telescoping light stands, and extension cords, as needed.

Test Panel for 35mm film: a 22×28″ (56×71cm) sheet of white illustration board, an 18×27″ (46×68cm) sheet of black illustration board, spray adhesive or double-stick tape, a set of 14″ (36cm) Kodak color separation guides (color control patches) and a gray scale (Kodak catalog no. Q–14), and four Kodak neutral test cards (Kodak catalog no. 152 7795).

Test Panel for 4×5" (101×124mm) film: a 28×34" (71×86cm) or larger sheet of white illustration board, a 24×30" (61×76cm) sheet of black illustration board, spray adhesive or double-stick tape, a set of 14" (36cm) Kodak color separation guides (color control patches) and a gray scale (Kodak catalog no. Q–14), and four Kodak neutral test cards (Kodak catalog no. 152 7795).

35mm Film: One roll of twenty-exposure film for each two lenses to be tested, as follows: (1) Daylight: ASA 64 or ASA 25 slide film. (2) Tungsten: ASA 160 (3200K) or ASA 40 (3400K) slide film.

4×5" Film: One box of ten sheets of film for each two lenses to be tested, as follows: (1) Daylight: ASA 64 transparency film. (2) Tungsten: ASA 32 (3200K) transparency film.

Accessories: A sturdy tripod, shutter release cable, masking tape, tape measure, notebook, loupe magnifier, hand-held slide viewer, easel and backing board (if working outdoors and no suitable exterior wall is available), small self-stick labels and one vinyl slide page for each roll of 20-exposure slide film used.

PROCEDURE IN TESTING EQUIPMENT
ASSEMBLING THE TEST PANEL: 35mm FILM

1. Place the black illustration board on the white illustration board so that there are 2" (5cm) wide white borders above and below and ½" (1.3cm) wide white borders to the left and right of the black board. Outline the position of the black board in pencil.

2. Spray adhesive or attach double-stick tape on the back of the back board (Figure 81A).

3. Align the edges of the black board within the penciled outline on the white backing board (Figure 81B).

4. Lower the black board, confirm that it is properly placed, then firmly press the black board down onto the white backing board (Figure 81C).

5. Carefully measure and mark the positions of the gray cards, gray scale, and color separation guide as follows (Figure 81D):

 a) Center two gray cards next to one another lengthwise across the bottom of the black board. Mark 3½" (9cm) borders to the left and right of the two adjoining cards, leaving a ¾" (2cm) border between the edges of the gray cards and the edge of the black board.

 b) Center the gray scale and color separation guide above and parallel with the gray cards. Each should be 6½" (16.5cm) from the left and right edges of the black board and separated by 1" (2.5cm) from the gray cards, each other, and the top edge of the black board.

6. Once you have outlined the positions of the gray cards, gray scale, and color separation guide, attach double-stick tape to or spray adhesive on the back of each and mount the cards where outlined on the black board (Figure 81E).

81. To assemble a test panel: (A) Adhesive is sprayed on the back of a black board or double-stick tape is attached to it. (B) The edge of the board is aligned within the border previously outlined on the white backing board. (C) The card is lowered, its position is checked, and the black board is firmly pressed to the backing board. (D) The positions of the gray cards, gray scale and color separation guide are carefully measured and marked. (E) All items are attached to the black board with spray adhesive or double-stick tape. (F) This is the way the completed test panel should look.

A

B

C

D

E

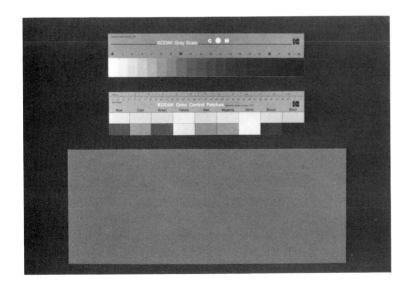

F

ASSEMBLING THE TEST PANEL: 4×5″ FILM

The procedure for assembling the test panel for 4×5″ (101×125mm) film is essentially the same as that used for assembling the test panel for 35mm film.

1. Place the black board on the white board so that there are 2″ (5cm) or wider white borders on each side of the black board. Outline the position of the black board in pencil.

2. Spray adhesive or attach double-stick tape to the back of the black board.

3. Align the edges of the black board within the penciled outline on the white backing board.

4. Lower the black board, confirm that it is properly placed, then firmly press the black board down onto the white backing board.

5. Carefully measure and mark the positions of the gray cards, gray scale, and color separation guide as follows:

 a) Center two gray cards next to one another lengthwise across the top of the black board. Mark 5″ (12.5cm) borders to the left and right of the two adjoining cards, leaving a 3″ (7.6cm) border between the edges of the gray cards and the edge of the black board.

 b) Center the gray scale and color separation guide below and parallel with the gray cards. Each should be 8″ (20cm) from the left and right edges of the black board. A 1½″ (4cm) space should separate the gray scale and color separation guide from the gray cards and each other, with a 4″ (10cm) space between the lower of the two and the bottom edge of the black board.

6. Once you have outlined the positions of the gray cards, gray scale, and color separation guide, attach double-stick tape to or spray adhesive on the back of each and mount where outlined on the black board.

PLACING THE TEST PANEL: INDOORS

1. Attach the test panel to a room wall with masking tape at all four corners. The panel must be held flat against the wall. Attach additional tape as necessary to maintain overall flatness.

2. The panel should be horizontal to the floor. The top of the 35mm film test panel should be 66″ (167 cm) above the floor. The top of the 4×5″ film test panel should be 69″ (175cm) above the floor.

PLACING THE TEST PANEL: OUTDOORS

1. Attach the test panel to a *flat* exterior building wall that receives side lighting between 10 AM and 2 PM. Walls that face east or west are suitable, but walls that face north or south should not be used. The wall must also receive direct sunlight with no shadows from tree branches, building overhangs, or overhead wires.

2. If no suitable exterior wall is available, mount the test panel on a board with masking tape and place the board on an easel in an area that receives proper lighting (Figure 82).

3. Adjust the easel so that the test panel is vertical.

82. When working outdoors, the test panel can be mounted on a board and placed on an easel. Note the use of cinderblocks at the base of the easel to prevent any movement. Be sure that the easel and test panel are kept as close to vertical as possible when photographs are taken.

4. The top of the 35mm film test panel should be 66″ (167cm) above the ground. The top of the 4×5″ film test panel should be 69″ (175cm) above the ground.

LIGHTING THE TEST PANEL: INDOORS

1. Assemble the lighting equipment and plug the lights into nearby outlets. (Make sure no appliances are connected so the same electrical circuit.)

2. If exterior daylight enters the room, close drapes, blinds, or shades so that no daylight enters. If this is not possible, wait until after sunset to perform the test.

3. Place each light 6 feet (2m) from the test panel to the left and right sides, and 3 feet (1m) from the wall on which the test panel is mounted (Figure 83).

4. Turn on the lights.

LIGHTING THE TEST PANEL: OUTDOORS

1. Select a day with full sunlight and few, if any, clouds or with a fully overcast, but not dark, sky.

2. Assemble the materials needed at any time, but perform the test between 10 AM and 2 PM.

CALCULATING THE BASIC EXPOSURE

1. Place fresh batteries in the exposure meter.

2. Set the ASA index on the exposure meter to the ASA rating of the film (Figure 84).

3. Using one of the two remaining gray cards, measure the illumination level at each of the six positions indicated (Figure 85). To do this, hold the gray card parallel to the surface of the test panel, making sure that no shadows are cast on the card by your hand or by the meter itself (Figure 86).

4. If the levels of illumination are the same at each of the six positions, as they should be in daylight, the panel is evenly illuminated.

5. If light levels are not the same at each of the six positions, move the lights toward or away from the work, or redirect the reflectors toward or away from the work, until even illumination is achieved.

6. Reconfirm that the work is evenly illuminated by repeating Step 3.

7. Once the test panel has been evenly lit, calculate an appropriate shutter speed and lens aperture and record the combination to be used in your notebook. Also record the brand name and ASA rating of the film along with the emulsion number. If you are working outdoors, indicate the date, time of day, and the lighting conditions (full sun, overcast, and so forth) under which you are working.

8. The meter need not indicate an exact match between shutter speeds and whole lens apertures. For example, the meter may indicate such combinations as f/16 at 1/125 second or f/11 at 1/250 second (Figure 87). But it may also read 1/125 second at a lens aperture midway between f/11 and f/16 (Figure 88). This is perfectly acceptable. A lens aperture midway between whole f/numbers will be written, for the purpose of clarity, as "f/11–16." This method will be used throughout the remainder of this book.

83. To light the test panel, place one light to the left and one light to the right of the test panel. Each light must be 6 feet (2m) from the outer edge of the test panel and 3 feet (1m) from the wall on which the panel is mounted.

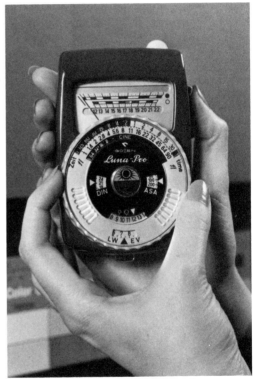

84. Adjust the ASA index on the exposure meter to the ASA rating of the film.

85. *Measure the level of illumination at each of the six positions shown by using either a reflectance meter and a separate gray card or an incidence meter. These six positions represent the approximate areas you will also be checking later when a painting is substituted for the gray rectangle.*

86. *Hold the gray card parallel to the surface of the test panel, making sure that no shadows are cast on the card by your hand or by the meter itself.*

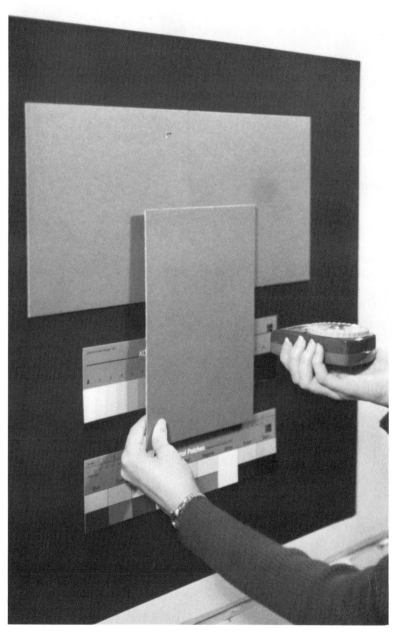

ADJUSTING THE CAMERA POSITION

1. Load the 35mm SLR with slide film.

2. Mount the 35mm SLR or 4×5″ view camera on the tripod.

3. Adjust the height of the camera so that the center of the lens is 55″ (140cm) from the floor or ground when the lens is horizontal.

4. Center the camera in front of the test panel. If you are working indoors, you can center the camera by measuring the distance from the center of the test panel to a nearby intersecting wall. Place the camera the same distance from the wall in front of the test panel (Figure 89).

5. Center the test panel in the SLR viewfinder or on the view camera ground glass and adjust the position of the camera and tripod so that:

a) A very small portion of the white border surrounding the black board is visible between the black board and the edges of the viewfinder frame or ground glass (Figure 90).

b) The white border is the same size on all four edges of the viewfinder frame or ground glass.

c) The rectangular shape of the black board is not distorted and the edges of the black board are parallel with the edges of the viewfinder frame or ground glass.

6. To remove distortion, identify the shape of the black paper as illustrated in Figures 91–94 and adjust the position of the camera as indicated.

Be sure to keep the black paper of the test panel centered at all times:

a) If the camera is too far to the right of center, move the camera gradually to the left while examining the image in the viewfinder/ground glass. Stop when the distortion is eliminated (Figure 91).

b) If the camera is too far to the left of center, move the camera gradually to the right while examining the image in the viewfinder/ground glass. Stop when the distortion is eliminated (Figure 92).

c) If the camera is too high and points down at the test panel, lower the camera gradually while examining the image in the viewfinder/ground glass. Stop when the distortion is eliminated (Figure 93).

d) If the camera is too low and points up at the test panel, raise the camera gradually while examining the image in the viewfinder/ground glass. Stop when the distortion is eliminated (Figure 94).

7. Diagram the position of the black paper of the test panel as it appears in the 35mm SLR viewfinder using the accompanying illustration (Figure 95) as a guide.

PROBLEM 1. *White borders surrounding the black paper are not equal.* If the white border is larger along the horizontal or vertical sides of the SLR viewfinder and it is apparent that no further adjustment will correct the inequality, merely center the black paper in the viewfinder so that parallel borders are equal. Keep the borders as narrow as possible (Figure 95).

87. *The meter may indicate lens aperture and shutter speed combinations such as f/16 at 1/125 second or f/11 at 1/250 second.*

88. *The meter may not indicate an exact correspondence between whole lens apertures and shutter speeds. For example, the meter may indicate a lens aperture between f/11 and f/16 at 1/125 second. This is perfectly acceptable. For our purposes, such a combination would be written "f/11–16 at 1/125 second," indicating that the lens aperture should be set midway between f/11 and f/16.*

89. Measure the distance from an intersecting wall to the center of the test panel (top). Place the camera directly in front of the test panel at this same measured distance (center).

90. Make sure that all three of the following conditions are met as the position of the camera is adjusted for proper location of the image in the viewfinder: (1) A small portion of the white border surrounding the black board should be visible between the black board and the edges of the viewfinder or ground glass. (2) This white border should be the same width on all four sides of the viewfinder frame or ground glass. (3) The rectangular shape of the black board must not be distorted. The edges of the black board must, therefore, be parallel to the edges of the viewfinder frame or ground glass.

91. *The camera is too far to the right of center. To correct this, move the camera gradually to the left while examining the image in the viewfinder/ground glass. Stop when the distortion is eliminated.*

92. *The camera is too far to the left of center. To correct this, move the camera gradually to the right while examining the image in the viewfinder/ground glass. Stop when the distortion is eliminated.*

93. *The camera is too high and points down at the test panel. To avoid this, lower the camera gradually while examining the image in the viewfinder/ground glass. Stop when the distortion is eliminated.*

94. *The camera is too low and points up at the test panel. To prevent this, raise the camera gradually while examining the image in the viewfinder/ground glass. Stop when the distortion is eliminated.*

95. *If the white border is larger along the horizontal or vertical sides of the SLR viewfinder and it is apparent that no further adjustment will correct the inequality, simply center the black board in the viewfinder so that the borders on parallel sides of the viewfinder are equal. Keep the borders as small as possible.*

96. *Always diagram the position of the black board of the test panel as it appears in the 35mm SLR viewfinder, using copies of this illustration as a guide. The proportions of this frame are exactly 1:1½, the same proportions as the film frame itself. Your diagram made within the frame can be compared to the processed film image to ascertain the correspondence between the image as you saw it in the viewfinder and the image actually recorded on the film.*

PROBLEM 2. *The test panel only fills the SLR view-finder correctly when behind the exposure information display in the viewfinder.* The test panel should not disappear behind the display area of the SLR viewfinder. Center the test panel as above. Be patient in adjusting the position of the camera. Remember, the only way to determine lens distortion and viewfinder accuracy is to be perfectly sure that no other forms of distortion are introduced by improper camera placement. With experience, this process, which is used in photographing two-dimensional works, will become second nature.

CAMERA PREPARATION: 35mm SLR

1. Attach the shutter release cable and advance the film.

2. Focus the lens on the detailed printing on the gray scale or on the color separation guide.

CAMERA PREPARATION: 4×5″ VIEW CAMERA

1. Attach the shutter release cable.

2. Cock the shutter and open the iris diaphragm.

3. Focus the test panel on the ground glass. Use the loupe magnifier directly on the ground glass for fine-focus adjustment.

4. Close the iris diaphragm and insert one sheet-film holder containing transparency film.

5. When the film holder is securely held, remove the film holder's dark slide on the side facing the lens.

EXPOSING THE FILM: 35MM

1. Take a series of exposures bracketed around the calculated exposure, written in your notebook as follows:

EXPOSURE NO.	LENS APERTURE
1	−2 stops
2	−1½ stops
3	−1 stop
4	−½ stop
5	exposure as calculated
6	+½ stop
7	+1 stop
8	+1½ stops
9	+2 stops

If you metered a shutter speed and aperture combination of ¼ second at *f*/8, for example, your exposure sequence would be as shown in the first table on page 102.

If you metered a shutter speed and aperture combination of ¼ second at *f*/8–11, for example, your exposure sequence would be as indicated in the second table on page 102.

2. Repeat the test sequence with a second lens to complete eighteen of the twenty exposures on the roll of slide film, but be sure to continue the numbering process for the second sequence by beginning with exposure no. 10 (leaving the ninth exposure blank).

3. Have the slide film processed promptly by the manufacturer.

EXPOSURE NO.	TIME	LENS APERTURE
1	¼ sec.	f/16
2	¼ sec.	f/11–16
3	¼ sec.	f/11
4	¼ sec.	f/8–11
5	¼ sec.	f/8 (as calculated)
6	¼ sec.	f/5.6–8
7	¼ sec.	f/5.6
8	¼ sec.	f/4–5.6
9	¼ sec.	f/4

EXPOSURE NO.	TIME	LENS APERTURE
1	¼ sec.	f/16–22
2	¼ sec.	f/16
3	¼ sec.	f/11–16
4	¼ sec.	f/11
5	¼ sec.	f/8–11 (as calculated)
6	¼ sec.	f/8
7	¼ sec.	f/5.6–8
8	¼ sec.	f/5.6
9	¼ sec.	f/4–5.6

4. The slides will be returned from processing in cardboard mounts. Each mount should have a number on it corresponding to the location of the film frame on the roll. The first frame will be numbered "1," the second "2," and so forth.

5. Write the exposure numbers in a vertical column down the left side of a piece of notebook paper. To the right, enter the shutter speed and lens aperture used for each exposure in the test sequence. Note the exposure that matches the lens aperture and shutter speed as calculated earlier. It should be the fifth exposure in the sequence.

6. When the film is returned from processing, the exposure information from the notebook should be transferred to the corresponding image. In other words, information for exposure no. 1 should be written on the mount of slide no. 1, and so forth. That way, if the notebook is misplaced, the information will not be lost (Figure 97). Also be sure to write the emulsion number of the film used on the outside of the slide box and on the cardboard mount of slide no. 5 (Figure 98).

EXPOSING THE FILM: 4×5"

1. Take a series of exposures bracketed around the calculated exposure and written in your notebook as follows:

2. Prior to exposing the film, write the exposure number and emulsion number of the film on a piece of paper and tape the paper to one side of the test board (Figure 99 (see page 87). Be sure to change the number for each subsequent exposure.

3. Write the information required for your records (see

EMUL. 5073 374

1/30 SEC F/11
EXPOSURE #5

EMULSION
#5073
374

97. (left) *Write the emulsion number of the film on a self-stick label and attach it to the vinyl slide page.*

98. (above) *Write the appropriate exposure information for each exposure on the processed slides' mounts in the sequence recorded in the notebook. Be sure to write the emulsion number of the film used on slide number 5 in your sequence.*

EXPOSURE	LENS APERTURE
SHEET 1	−1 STOP
SHEET 2	−½ STOP
SHEET 3	EXPOSURE AS CALCULATED
SHEET 4	+½ STOP
SHEET 5	+1 STOP

Step 5 of the preceding test) on a sheet of notebook paper. Unlike slides, processed transparencies are unmounted. Therefore, instead of the number found on the 35mm slide mount, the information that appears in the film image itself will be used to identify the number of the exposure in the test sequence.

4. Have the sheet film processed by a reputable professional color laboratory in your area immediately after exposure. If you cannot locate a local processor, consult the appendix for recommended laboratories.

5. When the film is returned from processing, transfer the exposure information from the notebook to self-stick labels and attach the labels to the mylar film sleeve in which the transparency is returned.

EVALUATING THE TEST RESULTS

The purpose of the test procedure was to familiarize you with basic photographic technique, as well as with problems and their solutions, and to eliminate many of the variables that can contribute, directly or indirectly, to poor image quality. Now that the tests have been completed, your ability as a photographer and the performance of your equipment can also be evaluated.

Ideally, the film images produced during the tests should be subjected to objective evaluation, but this is

simply not possible within the confines of a book. Subjective criteria, however, have been provided here that can be applied to these test results. This guidance should enable you to adequately assess the image quality of the tested films and the performance of your equipment.

The four principal aspects of image quality you will evaluate are: exposure, color fidelity, viewfinder accuracy in SLRs, and lens distortion. While it is not possible to touch upon every conceivable problem associated with image quality, or delve into the permutations of individual problems, major difficulties in each area of the evaluation will be discussed.

EXPOSURE

Accurate exposure depends on the performance of the exposure system, which includes both the exposure meter and the camera. Neither can be considered apart from the other in evaluating exposure. Remember, too, that film exposure is not a single event but a series of events culminating in the release of the shutter:

Prior to film exposure, the exposure meter must indicate lens aperture and shutter speed combinations appropriate to the lighting of the subject and the speed of the film. Any one of these aperture/shutter speed combinations should produce an "acceptable" exposure during film exposure, and should perform as expected throughout the exposure of the film. When the film is exposed and processed, the resulting images must correspond accurately to the subject as it appeared, within the reproduction limitations of the film itself.

If a problem in exposing the film occurs, you must determine which part of the system (exposure meter or camera) failed to operate as expected, and correct this so the problem does not recur. If the equipment operated properly, and if the test procedure was performed accurately, each twenty-exposure roll of film should contain two nine-exposure test sequences, and each five sheets of sheet film should represent one completed test sequence.

Each test sequence of 35mm film should contain (Figure 100, page 88): (1) four dark, underexposed slides, (2) one "acceptably" exposed slide, and (3) four light, overexposed slides. Each test sequence of 4×5″ film should contain (Figure 101, page 129): (1) two dark, underexposed transparencies, (2) one "acceptably" exposed transparency, and (3) two light, overexposed transparencies. Note that although only half a stop separates each of the exposures, they are distinctly different from one another. This is because, with color slide or transparency film, a difference of half a stop in exposures is quite significant and can result in accurate or inaccurate subject rendition.

Now organize the 35mm slides into three groups:

Group 1: exposures 1, 2, 3 or 10, 11, 12

Group 2: exposures 4, 5, 6 or 13, 14, 15

Group 3: exposures 7, 8, 9 or 16, 17, 18.

Also organize the 4×5″ transparencies into three groups:

 Group 1: exposure 1
 Group 2: exposures 2, 3, 4
 Group 3: exposure 5.

Examine the transparencies and slides in Group 2. Place the slides one at a time in the slide viewer and look at the transparencies against a strong light (Figure 102, page 130). Of the three images, select the one in which the entire gray scale has been most accurately reproduced, using the loupe magnifier, if necessary. Check to see that all individual steps in the gray scale are visible in the film image. Each gray tone must be distinctly different from adjacent tones, and no two adjacent tones should "merge" to form a single tone.

The transparency thus selected is the "properly" exposed transparency. If the lens aperture and shutter speed used to produce this transparency are not the combination indicated by the exposure meter and noted in the notebook and on the slide mount, as the proper one, note this discrepancy and adjust future exposures in accordance with this result.

For example, if 35mm slide exposure no. 4 or 4×5″ transparency exposure no. 2 is more accurate in its rendition of the gray scale than 35mm slide exposure no. 5 or 4×5″ transparency exposure no. 3, then future images may be exposed at half a stop *less* exposure than that indicated by the meter. Likewise, if 35mm slide exposure no. 6 or 4×5″ transparency exposure no. 4 is more accurate in its rendition of the gray scale, future images may be exposed at half a stop *more* exposure than that indicated by the meter. This assumes, of course, that the same lighting technique, film camera, and exposure meter will be used.

As you become familiar with the procedure of determining the "proper" exposure for your camera and exposure meter combination, continue to bracket exposures. However, bracket around the new "proper" exposure by one stop overexposure and one stop underexposure in one-half stop increments. When experience confirms that the initial test result was representative of your equipment and was not simply an accident, begin using a standard exposure. You may wish to continue to bracket exposures on occasion when slight underexposure or overexposure is necessary to bring out specific qualities, colors or tones in the work being photographed. At that point, your experience in making bracketed exposures will allow you to determine in advance what your exposure requirements are and how best to achieve them.

PROBLEM 1. *No properly exposed slide or transparency is to be found among the film images in my test sequence. All the images are too dark (or too light).* Either your equipment is faulty or malfunctioned, or you did not follow the instructions. Have your equipment tested by a

nearby photo dealer or by the manufacturer. Review your notes, making sure you set the shutter speed and aperture correctly for each exposure.

PROBLEM 2. *I cannot find a slide or transparency in which the gray scale tones are all visible and distinctly different. When the light tones are properly distinct, the dark tones merge and vice versa.* This problem occurred because the lighting used for the test was too strong and the film was unable to record the information in both the highlight and shadow areas of the gray scale at the same time. This problem is generally associated with full-sun illumination rather than with indoor, studio lighting. To remedy the problem, reduce the contrast of the light by waiting for an overcast day.

COLOR FIDELITY

Evaluation of image quality centers on color fidelity, rather than on grain characteristics, detail rendition, or contrast. Nonetheless, since detail and ultimate grain size are greatly dependent upon the grain size in unprocessed film, you should select a color slide or transparency film with the finest (i.e., smallest) grain size available for the light source to be used, and then photograph the work under controlled lighting. It must be remembered that color transparency films are inherently more contrasty than color or black-and-white negative films.

To achieve color fidelity, then, we must find a color film that exhibits neutral color character, neither adding nor detracting from the coloration of the original subject, so that the color in the film image appears as close to the original colors of the object as possible (Figure 102). Consequently, examination of transparencies for color fidelity should first center on the reproduction of that which we already know to be neutral in character, namely the 18-percent gray card. However, the reproduction of specific colors should also be determined.

To check for neutrality, examine the "properly" exposed slide or transparency to see if: (1) the gray card as reproduced is the same neutral gray as the original card; and that (2) each color in the color control patches, including intense hues and pastel tints, is rendered as in the original. If small changes have occurred between the original test panel and the film image, you can then assume them to be the result of inherent color characteristics of the film. On the other hand, overall gross distortion of colors would indicate an improper match of light source and film.

PROBLEM 1. *All colors except green are accurately reproduced.* Green is a touchstone color, one that some films do not reproduce well. If green colors appear in your work, repeat the tests with other films and the original light source, or test other light source and film combinations. In any case, you should look for a film that does a better job than the film initially tested.

PROBLEM 2. *The images have an overall "warm" (or "cool") character.* This is not unusual, since amateur films are designed to enhance the appearance of the subjects they record. In most cases, amateurs photograph people or places. When photographing people, "warmth" is desirable because it enhances the complexion. In outdoor photographs, "coolness" enhances the sky. The extent to which these characteristics enhance or detract from works of art must be made on an individual basis and depends on the nature of the specific work being photographed.

VIEWFINDER ACCURACY
Viewfinder accuracy is generally not a problem for $4 \times 5''$ film users because the image seen on the ground glass of the view camera is the same as that recorded on the film. However, the image seen in the viewfinder of the SLR and that recorded on the film are not usually the same. The difference may be slight and insignificant, or its significance can make accurate image placement on the film extremely difficult.

While the image seen in the SLR viewfinder is not subject to parallax error, the image seen through the viewfinder is only a portion of the image actually recorded on the film. One does not usually notice a difference between the two images because they are not seen at the same time. The viewfinder image is fleeting, and the amateur photographer is usually delighted to discover photographs that contain more of the subject than anticipated.

Fortunately, some camera manufacturers disclose the accuracy of their camera's viewing systems and express the image viewed as a percentage of the image photographed. But while 95 or 97 percent viewing accuracy is good, we still need to know how the extra 5 or 3 percent is distributed. To do this, we cannot rely on memory but must compare what was seen in the viewfinder to the resulting film image.

DETERMINING VIEWFINDER ACCURACY
You can compare the diagram of the test panel as seen through the viewfinder and recorded as part of the test procedure with the actual film images to determine viewfinder accuracy. Although you cannot determine the percentage relationship between them, you will still be able to determine how the excess image is distributed within the film frame.

To compare the images viewed and photographed with the SLR, remove slide 3 (or 12) from its cardboard mount. (Save the mount itself.) Holding the film by its edges, examine the width of the white border surrounding the black paper of the test panel. Compare the film image with the notebook diagram. You may spot one of the following:

1. CHANGE OF LOCATION. If the image was centered in the viewfinder with equal white borders but is not centered on the film and has unequal borders, note the shift in location as "toward the lower left corner," or "toward the right center," and so forth.

2. CHANGE IN SIZE OF BORDERS. If the image had equal borders in the viewfinder and was centered, and is centered in the film image but with larger borders, note if: (a) the borders are larger but proportionately equal or (b) the borders are larger but are not proportionately equal. If unequal, which sides have the largest borders?

3. IMAGE TILTED. If the image was squarely located in the center of the viewfinder but now appears askew or tilted in the film image, indicate the direction of the tilt and its severity. For instance, you may write "slight tilt toward lower left corner" or "severe tilt to lower right corner."

ADJUSTING THE CAMERA
The following suggestions will help you adjust the position of the camera in the future to compensate for the inaccuracy of the camera's viewing system:

1. LARGER BORDERS. If the borders are larger than anticipated, move the camera slightly closer to the work than the viewfinder indicates is acceptable.

2. UNEVEN BORDERS. If the borders are larger along the right and bottom, left and bottom, left and top, or right and top sides, than anticipated, shift the image accordingly toward those sides so that the size of all four borders is equalized in the film images.

3. TILTED IMAGE. If the image is tilted slightly to the lower right or lower left corners of the film image, tilt the camera a slight amount in those directions so that the resulting images appear square.

Additional testing may be necessary to confirm the accuracy of these adjustments. Exercise the same care in these secondary tests that you did in the first test sequence. By understanding the characteristics of your

camera's viewing system you will avoid unnecessary confusion in the future. Therefore take the time at this stage to make the necessary determinations and adjustments.

LENS DISTORTION

When you compare the edges of the film frame with the edges of the black paper in the film image (Figure 103), barrel distortion and pincushion distortion may be evident. (Slide exposure 3 and transparency exposure 3 can be used for the comparison.)

Nothing can be done to correct such lens distortion except to change to a different lens. Also remember that a longer focal length lens reduces perspective distortion, which is sometimes confused with lens distortion. Therefore, normal and shorter focal length wide-angle lenses should not be used for the tests or when photographing small or medium-size objects unless these are the lenses you intend to use in photographing these works. Even so, when these lenses are used to photograph such objects, perspective distortion will result.

6. PHOTOGRAPHING ART

To produce the highest quality photographs, you must not only use the proper equipment; you must also use the proper technique. "Technique" is the ability to skillfully operate camera and lighting equipment to produce faithful photographic reproductions of works of art. Consistently accurate exposures of properly composed and focused images can only be obtained by study and practice.

Photographic technique varies according to the size of the work area and its location, the size and medium of the objects being photographed, and the type of lighting and camera equipment used. It also varies with the imaginativeness, inventiveness, and thoroughness of the photographer. Techniques of photographing works of art are easily learned, and the procedures presented in this chapter will guide you step by step through the fundamentals of photographing two- and three-dimensional works of art.

SELECTING A WORK AREA

One key to successfully photographing works of art is lighting control. Most commercial photographers work in studios where lights and lighting can be easily regulated. The studio photographer works in a specific location and uses indoor studio lighting equipment. Working outdoors under daylight conditions offers much less lighting control. Of course, the outdoor photographer has a much larger work space than the studio photographer.

Lighting control is not the only factor that should be considered in the selection of a work place. You must also consider the portability of your equipment; the size and character of the works of art to be photographed, as well as their locations; and your general photographic requirements.

Large-format equipment, along with its numerous ancillary pieces, is cumbersome to transport. The view camera is fundamentally a studio instrument. Conditions outside the controlled studio environment, over which you have little control, are especially vexing to the view camera user, who must exercise meticulous control at all times in order to take full advantage of the view camera's superior image size.

Many works of art are designed for particular environments, and removing them from the environment in which they should be seen in order to photograph them is an injustice to the works themselves. Other works may not be freely relocated for photographing because their structure, size, or construction may not allow it. Thus, when you select a location, consideration must always be given to the objects being photographed.

Finally, your own photographic needs should be estimated. If slides or prints are only occasionally required, outdoor seasonal changes need not be considered. If they

are regularly needed, seasonal changes may affect your ability to provide the materials.

THE INDOOR WORK AREA

The indoor work area must be unobstructed and free of clutter. It must be large enough to accommodate both the photographic equipment and the objects to be photographed, with proper working distances between them. Both large objects and long focal length lenses require long camera-to-object distances.

Plan your work area in accordance with the largest object to be photographed so that all objects can be accommodated. Allow at least six feet (1.8m) of working space on each side of the largest object so that there will be sufficient space for lighting equipment. Remember that lights placed farther from the sides of each object distribute light more evenly over the surface of the object than lights placed closer. Light sources placed too close to an object will cause uneven lighting, increased lighting contrast, and, because of the heat generated by the lights, may even damage the object. Very large objects, more than eight feet (2.4m) long or high, should be photographed outdoors unless an extremely large work area and numerous light sources are available. Even under ideal conditions, large works cannot be evenly illuminated in a relatively small studio with limited lighting equipment.

One wall of the work area will usually serve as a background for the object being photographed. The wall should be smooth, free of marks or blemishes and obstructions, and of a color that complements the object to be photographed. Stucco and other textured surfaces are not suitable as backgrounds for works of art.

If necessary or desired, cloth or paper backdrops can be placed over the wall either to complement the color of the object or to cover an otherwise unacceptable wall surface or color (Figure 104). You can purchase paper background materials in black, white, and a variety of colors from photo equipment dealers. The paper is usually available in sheets or rolls of various sizes and can be reused if carefully handled. Should you prefer fabric as a backdrop, you can get plain fabrics from fabric stores. But since the fabric will appear in the film image, make sure the fabric is large enough to cover the background area behind the object.

Black cloth or paper background materials are especially useful when photographing two-dimensional objects because they form a black border around the work of art in transparencies and slides. This eliminates the time-consuming task of masking individual slides with opaque black tape to eliminate distracting backgrounds. Whether cloth or paper materials are used, they must be free of blemishes and perfectly smooth.

Two-dimensional works can be hung directly on the wall using a nail driven through the cloth or paper back-

104. Gray paper, black cloth, or white paper can be used as background material. Note that the material "flows" over the table with no creases or folds visible.

drop into the drywall or plaster. If you do not wish to mar the wall surface, it will be necessary to use a table support beneath the work. A table support can be placed beneath the backdrop attached to the wall so that the material flows continuously down the wall and over the table. (The size of the table used depends on the sizes of the objects being photographed and their weights.) A continuous piece of background material reduces the folds and seams that sometimes appear in slides and photographs and that detract from the appearance of the object. Substituting an easel for the table is not recommended, however, because it is difficult to drape backdrops, particularly paper ones, over an easel without creasing and distorting them.

Lighting equipment should be connected to an electrical circuit that is separate from the one used by major appliances, such as washers, refrigerators, and air conditioners because such appliances cause unpredictable loads on a circuit, resulting in appreciable changes in line voltage. These in turn affect both the light output and the color temperature of photolights.

Overall power reductions, or "brown-outs," which generally occur during the summer months when demand for electricity is high, are also reductions in line voltage and adversely affect the light output and color temperature of photolights. If a "brown-out" occurs in your area, wait until it ends and line voltage is fully restored before you begin photographing.

If you are working during daylight hours, remember that daylight must not enter the work area. Daylight mixed with tungsten light does not match the color temperature of light required for either tungsten or daylight film. In other words, color will be inaccurately reproduced in photographs taken with tungsten-balanced film and a mixture of tungsten and daylight illumination. Daylight can be blocked out by drawing drapes or shades and, if necessary, by covering window openings with opaque black paper or several thicknesses of black cloth. If this is impractical, wait until after sunset to take your photographs.

The tripod upon which the camera should be mounted must itself be firmly supported to prevent camera motion during film exposure. A thick rug with sponge underpadding is not a stable support for the tripod. Therefore, if possible, remove or roll aside all rugs. If they cannot be moved, put a large board over them and place the tripod on top of the board. This will provide the necessary stability.

THE OUTDOOR WORK AREA

The most important consideration in selecting a suitable outdoor work area is lighting. Unobstructed lighting is essential, particularly if direct sunlight is to be used. The path of light near the work area must be free of tree limbs and branches as well as overhead wires that might

cause shadows to be cast over the objects being photographed.

There are two types of lighting outdoors, direct sunlight and overcast daylight. Direct sunlight is harsh and contrasty. While a high level of illumination falls directly on one part of the subject being photographed, very little light falls on areas shaded from the direct light. Overcast daylight, on the other hand, is diffuse and less contrasty, and the difference in the levels of illumination striking various areas of the subject, while measurable, is less dramatic. The choice of lighting conditions ultimately depends on the objects being photographed and the effect light has upon their appearance.

Avoid taking photographs on partly sunny or partly cloudy days because passing clouds will cause great changes in lighting and in exposure readings, causing delays in picture-taking. Also avoid photographing in the shade of a building on a sunny day because under sunny conditions, the shadows of buildings are saturated with blue skylight. This will cause color slides and prints to appear abnormally blue. Finally, avoid taking photographs when it is breezy because camera, tripod, or object can be moved by even a slight breeze.

Also keep in mind that foliage changes color or disappears as the seasons change, so if it is to be used as a background for objects, plan your photographic sessions accordingly. Outside temperature and weather conditions will also change from day to day and from season to season, thus limiting the availability of the outdoor work area.

Flat exterior building walls, garage doors, and other vertical surfaces are usually unsuitable in themselves as backgrounds for objects, though they can be used to support cloth or paper background materials such as those already discussed in the previous section. In this case, you would place a table against the wall to support objects while they are photographed. As always, the tripod upon which the camera should be mounted must be supported on firm ground.

ORGANIZING OBJECTS

To prevent constant adjustment of the positions of the camera and lights throughout the work session, it is best to separate the objects to be photographed into groups according to size and medium. Organize each group so that the objects within it progress from smallest to largest, or largest to smallest. By photographing the works in an orderly progression of size, excessive camera movement will be avoided.

Organize paintings according to stretcher or sight size rather than frame size, and show as little of the frame as possible in each photograph. In fact, to avoid any possibility that the frame might cast a shadow across the face of a painting, it is best to remove it altogether.

Matted works—such as prints, drawings, watercolors,

and other works on paper—whether framed or unframed, should be organized according to mat opening or mat window size. Do not organize by mat size alone. It is not necessary to remove works under glass from behind the glass or from their frames, but mylar wrappings should be removed from matted works to avoid spurious reflections of the lighting on the mylar, if it should buckle.

Sculptures should be grouped by size, medium, and surface texture. Highly reflective materials, for instance, may require a lighting arrangement different from that of matte-surfaced objects. So although they may be the same size, it is more important that objects be separated by medium and surface texture before being organized by size.

BASIC LIGHTING

Basic lighting is the starting point from which variations can be made according to the size, medium, construction, and location of the object to be photographed. Basic lighting for two-dimensional works is that normally used to evenly illuminate the surface of the work. Some small adjustments may be required but, in general, basic lighting is standard lighting for two-dimensional works of art.

On the other hand, basic lighting for three-dimensional works is designed not only to illuminate the object, but also to portray the mood, atmosphere, and spatial relationship of the object to its environment. The interplay of light and shadow is also usually an important characteristic of sculptural works of art. Consequently, lighting arrangements should be designed with these factors in mind.

Basic two-dimensional lighting consists of two, four, six, or more lights evenly divided between the left and right sides of the object. The lights are placed a suitable distance from the object at an angle that minimizes direct reflections of light from the surface of the two-dimensional object (Figure 105). If the texture of the work needs to be highlighted slightly, or if the work was produced under overhead lighting and appears best when this type of lighting is duplicated while photographing the object, you may want to adjust the lights so slightly more light falls on the work from above. This stronger overhead light better reproduces the conditions under which the work was created and is particularly suitable for works with textured surfaces. If you are unable to direct the light itself downward onto the top of the work to achieve this effect, you can turn (or hang) the work sideways so its top edge is now at your left or right, and then move the light nearest to that edge slightly closer to the work. That way, the textural qualities are perceived as they would have been had the light fallen from above when the work was upright.

Basic three-dimensional lighting features a single dominant or main light. This light illuminates the object, establishes its relationship to its surroundings, sets a

105. Basic two-dimensional lighting.

mood, and causes shadows that add volume and sub-
stance to the work itself (Figure 106).

Additional accent or fill lighting is then used to aug-
ment this main light and illuminate the shadowed areas
of the object. Indirect illumination obtained, for example,
by bouncing light off a ceiling or other reflective surface
(Figure 107) provides fill lighting without adding addi-
tional shadows that might add confusion to a final
photographic image. Lighting should be thought of as a
sculptural element illuminating the work while establish-
ing form and drama.

Three-dimensional lighting arrangements should be
evaluated before you take the picture rather than in the
final photographs. So examine the subject carefully
through the camera's viewfinder while lighting arrange-
ments are considered. Do not be discouraged if you
cannot immediately determine the best lighting arrange-
ment. It may be necessary to experiment for a time
before you find one that is suitable. Until then, photo-
graph objects under various lighting setups. You may
even wish to try photographing three-dimensional objects
from different viewpoints, if the work is to be seen "in
the round."

LIGHTING AND CONTRAST

Contrast in film images depends both on the range of
tones contained in the subject and on the lighting il-
luminating the subject while it is being photographed.
Contrast is expressed as a ratio of the lightest to the
darkest areas of the subject (subject contrast or subject
brightness range) or as a ratio of the stronger to the
weaker light in a lighting arrangement (lighting con-
trast).

106. Basic three-dimensional lighting.

The reflectivity of light and dark areas in the subject does not change under different lighting conditions. That is, a black velvet surface absorbs most of the light that strikes it, while a white panel reflects most of the light that strikes it. This is true regardless of the lighting conditions. However, the amount of light actually reflected from each surface is wholly dependent upon the amount of light striking it.

SUBJECT CONTRAST

Subject contrast is the ratio of the light reflected by the most reflective tones in the subject to the light reflected by the least reflective tones in the subject *when the subject is evenly illuminated.* (You can check to see that the illumination is even by using a gray card and a reflectance meter.) Once even illumination is established, you can measure the difference in reflectivity between the darkest and lightest tones with the reflectance meter. Place the meter close to the surface of the object so that only light reflected from the desired area is measured. You can also use a type of reflectance meter called a "spot" meter (Figure 108) for this. The spot meter has an extremely narrow angle of view and does not need to be used close to the object to obtain accurate measurements.

The reflectance meter measures the light reflected individually by the lightest and darkest areas of the subject and indicates an appropriate combination of lens aperture and shutter speed for each. While making these measure-

107. Indirect fill lighting provided by a reflector.

ments, use a constant shutter speed and note the apertures required at that shutter speed for each of the two areas.

A typical pair of meter readings might be as follows:
Lightest area: *f*/11 at 1/125 second
Darkest area: *f*/4 at 1/125 second

Each change of one stop in the sequence of lens apertures indicates a halving or doubling of the amount of light reflected by the subject. The number of stops separating the meter readings for both the light and the dark subject areas can be easily converted into contrast ratios using the following table:

DIFFERENCE IN REFLECTIVITY	CONTRAST RATIO (LIGHT-TO-DARK)
1 stop	2 : 1
2 stops	4 : 1
3 stops	8 : 1
4 stops	16 : 1
5 stops	32 : 1
6 stops	64 : 1
7 stops	128 : 1

The difference in reflectivity between apertures *f*/11 and *f*/4 is three stops (Figure 109). This corresponds to a contrast ratio of 8:1.

It is extremely difficult to calculate contrast ratios for subjects that are essentially monochromatic: for example, white-on-white or black-on-black paintings, paper embossments, and pencil drawings on white paper. The contrast of such subjects is generally less than 2:1 and is described as "low."

LIGHTING CONTRAST
In measuring subject contrast, the illumination is even and you note the difference between the lightest and darkest areas on the subject. In measuring lighting contrast, on the other hand, the illumination on the subject is *uneven* and you note the ratio of the most intense light to the least intense light falling on the subject. As mentioned earlier, lighting contrast is measured using a reflectance meter and a gray card.

To measure lighting contrast in the studio, the main light alone is first turned on. Then the gray card is placed at the center of the work and the light reflected from it is measured (Figure 110 A, B). The main light is then turned off and the fill light turned on. Again, the light reflected from the gray card is measured (Figure 110 C, D). Using the preceding table, the lighting contrast ratio is calculated by noting the difference in lens apertures at the same shutter speed indicated during the two meter readings.

In measuring lighting contrast on two-dimensional works, the lighting should produce a ratio of 1:1. In other

108. *A spot exposure meter, which can be used to measure light reflected by small areas on the surface of the subject, is a form of reflectance meter. It is extremely useful in determining subject contrast, especially when the darkest and lightest portions of the subject consist of very small areas.*

109. *A difference in meter readings (at a constant shutter speed) between f/11 and f/4 is three stops. This corresponds to a contrast ratio of 8:1 between the lightest and darkest areas of the subject.*

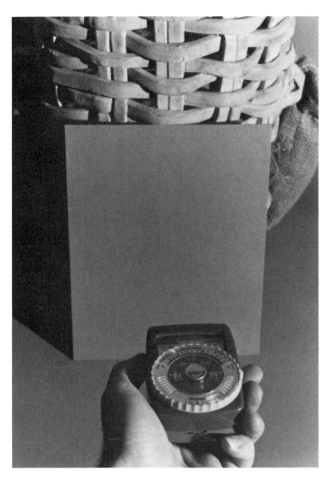

B

110. To determine the contrast ratio of the lighting: (A) The main light is turned on and the light reflected off the gray card is measured. (B) This is the meter reading for ASA 125 film.

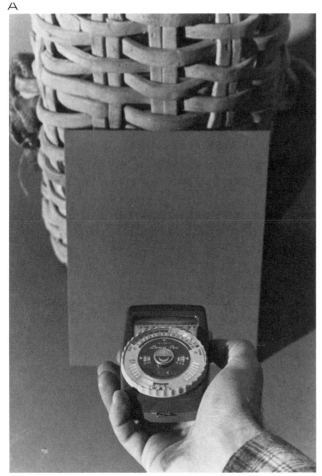

C

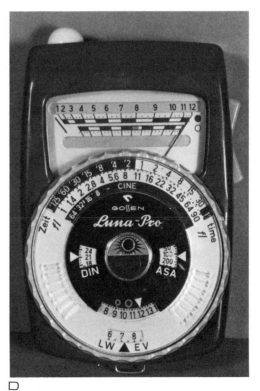

D

(C) Next, the reflectance meter measurement is taken using fill light only. (D) The difference between the two readings is the contrast ratio of the lighting; here one stop, a 2:1 ratio.

111. *Light reflected from any and all nearby surfaces is considered fill light when only one main light is used.*

112. *To measure the level of illumination reflected by nearby surfaces, the fill light must be isolated from the main light. To do this, fold a 12 × 20"(30 × 51 cm) piece of black illustration board with the black surface facing inward. Mount a gray card on one of the inside surfaces. Place the board in front of or at the position of the work. The main light will be blocked out by one part of the folded board and will not, therefore, strike the gray card on the other. The fill light can then be measured by reflection from the gray card unaffected by the level of illumination provided by the main light.*

words, the exposure meter should indicate the same light levels for both lights or sets of lights illuminating the work. Obviously, since both light levels are equal, it does not matter which set of lights is considered the main light and which is considered the fill light.

Basic lighting of three-dimensional works should generally produce a lighting ratio of 2:1, 3:1, or 4:1. Although these ratios are used in portrait photography, they are also applicable to three-dimensional works of art. When only one light is used to illuminate the subject (when using daylight or one studio light), light reflected by nearby surfaces may fall on the subject (Figure 111). Reflective surfaces are also light sources, and the light reflected from such surfaces is considered fill light.

To isolate main light from indirect fill light produced by the main light, a small, opaque screen and gray card can be placed in front of or at the location of the subject. Fill light can then be measured accurately and independently of the main light (Figure 112).

CONTRAST AND FILM

Lighting contrast must be controlled so that the film can record details in both the highlight (light) and shadow (dark) areas of the subject. To avoid excessive contrast and loss of detail in color transparencies, the ratio of light to dark areas of the work being photographed should not exceed 10:1 under the lighting selected, a ratio easily maintained with studio lighting equipment.

The average black-and-white film can record highlight and shadow detail within a contrast ratio of approximately 128:1. However, glossy black-and-white printing papers can only reproduce a contrast ratio of 50:1. Thus, unless the contrast of the subject recorded on the film is limited to between 32:1 and 50:1, more information may be recorded on the film than can be successfully transferred to the print.

Remember that the contrast ratio discussed in relation to film is not simply *subject* contrast or *lighting* contrast. Even though subject contrast and lighting contrast are measured independently, in practice, they interact. This is because, regardless of its characteristic or intrinsic contrast, the contrast of a subject increases or decreases with changes in lighting. And the relationship between subject and lighting contrast allows you to determine the ultimate contrast of a subject as recorded on film.

The relationship between subject and lighting contrast can be determined mathematically. To determine the image contrast as recorded on the film, multiply the subject contrast ratio by the lighting contrast ratio. For example, if a subject with a contrast ratio of 4:1 is illuminated by lighting with a contrast ratio of 8:1, the resultant contrast of the subject is:

$$\frac{4}{1} \times \frac{8}{1} = \frac{32}{1} \text{ (or 32:1)}.$$

In other words: subject contrast × lighting contrast = image contrast. By knowing the limits of color transparency film (10:1) and black-and-white printing papers (50:1), it is simple to determine the lighting required for subjects of specific contrasts.

You may have to experiment at first to determine how particular lighting arrangements will affect image quality, highlight and shadow rendition, and ultimate image contrast in transparencies and prints. But you will soon discover that careful adjustments in studio lighting—for example, moving the lights closer or farther away from an object—can then be made so that the full range of tones in the subject will be accurately reproduced.

Outdoors, where full-sun daylight can create lighting ratios in excess of 100:1, even more care must be exercised in controlling lighting. One way to control contrast is by using reflectors to direct light onto shadowed areas of the subject. Or photograph only on overcast days when the contrast in illumination is lower.

BASIC PROCEDURES FOR PHOTOGRAPHING ART

The procedure to be followed when actually photographing works of art is essentially the same as that used when testing and evaluating equipment. The procedure should be, in short, the culmination of everything learned to this point. Naturally, as problems occur some adjustments in technique will be necessary. However, at the outset of photographing objects, the basic procedures enumerated below should be followed.

EQUIPMENT AND MATERIALS REQUIRED

The following equipment and materials should be assembled:

Camera: 35mm SLR or 4×5″ view camera and tripod.

Lenses: All lenses previously tested as satisfactory, in focal lengths suited to the sizes of both the objects and the work area.

Exposure Meter: Hand-held reflectance or incident meter, or built-in through-the-lens meter.

Lighting: Daylight or tungsten (3200K or 3400K) light sources as previously selected and used in testing procedures, polarizing filters, reflective panels.

Film: 35mm or 4×5″ color transparency or black-and-white film, as required, in accordance with test results.

Display: Support table to hold works during photographing, paper and/or cloth background materials.

Miscellaneous: Masking tape, thumbtacks, filters, lens shade, black cloths, 18-percent reflectance neutral test cards (2).

SETTING UP EQUIPMENT: INDOORS

First select an appropriate work area. Then set up your equipment as follows:

1. Open the light stands, mount the reflectors, and insert the incandescent lamps.

113. Two-dimensional works sometimes cannot be focused on accurately because the work is relatively featureless. Placing a film data sheet at the plane of the work will allow accurate focusing. This may also necessitate the assistance of another person while you focus the lens.

2. Attach necessary extension cords and plug in the lights.

3. Open the tripod to a height of five feet (1.5m).

4. Load the 35mm SLR with a film selected in accordance with the test results (see Chapter 5).

5. Attach the shutter release cable to the camera.

6. Attach the viewfinder magnifier to the SLR camera.

7. Mount the camera on the tripod.

8. Center the table support against the background wall.

9. Attach background materials, if required, to cover both the background wall and the table.

10. Place one work of art in the center of the table.

11. Place the lights equal distances from the work to the left and right of the work table.

12. Place the camera and tripod directly in front of the work.

SETTING UP EQUIPMENT: OUTDOORS

1. Open the tripod to a height of five feet (1.5m).

2. Load the 35mm SLR with a film selected in accordance with the test results.

3. Attach the shutter release cable to the camera.

4. Attach the viewfinder magnifier to the SLR camera.

5. Mount the camera on the tripod.

6. Center the table support against the background wall.

7. Attach background materials, if required, to cover both the background wall and the table.

8. Place one work of art in the center of the table.

9. Place the camera and tripod directly in front of the work.

TAKING THE PHOTOGRAPHS

The sequence of steps to be followed when taking the actual photographs is similar to that used during the tests outlined in Chapter 5:

1. Turn on the photo lights.

2. Adjust the positions of lights and reflectors for basic lighting of two-dimensional or three-dimensional objects. At this point, problems may develop, such as: glare on the surface of paintings; specular reflections on highly polished materials; reflections on glass covering watercolors and prints; and so forth. If so, see the next chapter before proceeding further.

3. Take exposure measurements, as you did earlier during the tests.

4. Use results of the exposure measurements and previous tests as a basis for setting the shutter speed and lens aperture.

5. Position the work being photographed in the viewfinder of the camera so it is not distorted. Adjust the location of the image in the SLR viewfinder to correct for inaccuracies in the camera's viewing system.

6. Focus the art in the viewfinder. Check your focusing with the viewfinder magnifier or loupe.

7. If you cannot focus accurately on the object because of the nature or composition of the work, place (or have someone hold) a film data sheet at the plane of focus for two-dimensional works (Figure 113) or in the middle or front one-third of three-dimensional works (Figure 114).

8. Prepare the camera as follows: (a) Cock the shutter, insert one sheet film holder, and remove the dark slide for 4×5″ cameras. (b) Advance the film one frame with SLRs.

9. Release the shutter by pressing the shutter release cable.

10. Repeat Steps 8 and 9 for each additional exposure.

11. Repeat the procedure for each work or group of works being photographed.

114. Three-dimensional works are also sometimes difficult to accurately focus because of their featureless nature. Here the film data sheet is placed at the front of the work. If the work had more volume, it would be better to place the sheet nearer the center of the work and use the aperture to control depth of field for apparent focus for the work as a whole.

7. PROBLEMS AND SOLUTIONS

To solve a photographic problem, you must first identify it and locate its cause, then try to correct or eliminate it. Sometimes the cause of the problem is in the work itself, making it impossible to fully correct. When this occurs, you must compromise and photograph the work with the understanding that the results will be less than perfect. But other problems can be solved more easily.

Since it is impossible to discuss every problem you are likely to encounter in photographing works of art, only solutions to commonly encountered problems will be presented here. Nonetheless it is hoped that the process of resolving these general problems will establish a broad framework for approaching your own individual problems systematically.

One way to begin strengthening your ability to solve photographic problems is by critically examining photographs of common household objects in magazine advertisements, store catalogs, and newspaper supplements. Try to analyze the problems involved in taking these photographs and how they were solved. Even though these objects are not art, the problems involved are the same, and so are the skills and techniques necessary to solve them. After all, both artist and merchant are presenting and selling objects, and both need high-quality photographs.

To extract the information contained in a photograph and then interpret that information usefully, you need to analyze it systematically. To do this you must identify the following:

1. The location of the object.
2. The character of the lighting.
3. The light source.
4. The direction of the light in relation to the object.
5. Specific features of the object: the materials it is made of, its texture, and its surface reflectivity.

Make a copy of the accompanying chart (opposite) and use the terms provided to examine photographs of objects with the same surface texture, size, surface reflectivity, and so on as the works of art being photographed.

Fill out a separate chart for each photograph. After several charts have been filled out, you will find that certain patterns will emerge. For example, similar light sources, lighting positions, and types of backgrounds will consistently appear in photographs of similar objects. These results will indicate quite clearly that, whatever the technique employed by the photographer, these particular arrangements of lights, objects, and backgrounds are most suitable for photographing the object.

Use the illustrations in the color section (Figures 115-119) to identify the direction of light sources and the camera equipment used. In addition, as you examine the

Location:	Indoors	Outdoors
Lighting:	Diffused Harsh	Diffused Harsh
Light source:	Large light panel Spotlight Reflectors	Overcast Full daylight Sun and clouds
Light direction:	From above At object level From below	
Type of Object:	Two-dimensional: Three-dimensional:	

Material(s):

Surface Texture:

Reflectivity:	High	=	Glossy Highly polished Shiny Glasslike
	Medium	=	Dull Slight texture Polished
	Low	=	Matte Deep texture Coarse surface No polish

photographic reproductions of these objects, try to answer the following questions:

1. Are the devices used to light the object visible as images reflected in the object itself? Are lights or reflective panels visible as reflections in glassware, silverware, or glazed porcelain?

2. Can the location of the light sources be described based on the reflections themselves or other reflections evident in the object? Are table edges or other nearby objects also reflected? Can this information be of use to you in locating backgrounds, foregrounds, light reflectors, or other control devices?

TEXTURE: PAINTINGS (FIGURES 120-129)

Texture in paintings is composed of three elements: The primary element is surface irregularity. The second element, although not strictly a "part" of the texture itself, is shadow. And the third element is surface gloss or reflectivity. In treating texture as a problem, all three elements must be considered. However, of the three elements, the most important is surface gloss.

When varnish or acrylic gloss medium is applied as a final coat to a painting, it deepens and enriches its color, and provides a protective coating to the layers of paint beneath. Surface gloss is desirable on smooth-surfaced works, but not on textured works.

The raised, irregular surface of glossy, textured works reflects light from each raised point of paint on the surface. As a result, no matter where direct light sources (the sun or photo lights) are located to illuminate the work, reflections will be evident in the work's texture. These reflections appear as a whitishness, glare or "washing out" of color across the textured surface. Because such glare is difficult to fully control, if at all possible, textured works should be photographed before they are varnished.

On the other hand, you may want to emphasize the textured surface of textured works. To do this, you must preserve the shadows cast across the textured surface by the light. This is especially easy to do when the work is a light color. But you will find that dark-colored, textured works, especially when varnished, are extremely difficult to photograph. Shadows are nearly lost in the dark colors of such works, and the varnished surface reflects innumerable small points of light that interfere with the overall character of the object. Since shadowing must not be harsh or confusing to the nature of the work as a whole, in a situation such as this, involving dark textures, direct lighting of the work may be undesirable. Unless direct lighting enhances the overall appearance of the work, you will find that indirect illumination, which creates diffused shadows, will preserve the textural character of the work without creating shadow patterns that detract from the appearance of the work itself.

120 (left). *William H. Titus,* Glue Gun Madness, *acrylic on canvas. The work is illuminated by the sun, which is located to the left of the work. The sun's rays are almost parallel with the surface of the work. This causes a heightening of the effect of shadowing and is called "raking light." Raking light enhances shadowing at the expense of accurate color rendition and reproduction of the work as executed. Therefore, in general, this type of lighting should be avoided.*

121 (above). *This approximately same-size detail shows the effect of raking light in the delineation of texture.*

122 (left). *Here the painting and camera have been repositioned so that the light of the sun strikes the work at a less oblique angle. While some shadowing is still evident and adds to the textural qualities shown in the photograph, gray tones and color rendition have also been accurately reproduced. This lighting technique is superior to raking light.*

123 (above). *This detail shows the effect of changing the positions of camera and object for less oblique daylight illumination.*

124 (left). *Here the work is illuminated by diffused daylight from an overcast sky. While shadowing and texture are clearly visible, the tonal qualities and coloration of the work are not impaired. This photograph, especially in comparison with those made under direct sunlight, is a more accurate rendition of the work as a whole.*

125 (above). *This detail shows that the shadows formed by indirect illumination lack hard edges but still indicate the textural quality of the work. Comparison with Figure 154 shows the effect of harsh daylight illumination on overall tonal rendition.*

126 (left). *In this example, the work is illuminated in a studio with basic two-dimensional lighting. Although the shadows created by this lighting are less harsh than under direct daylight illumination, there are now two areas of shadow for each area of texture.*

127 (above). *This detail shows the confusing shadow patterns caused by this basic, two-dimensional lighting.*

A

B

C

D

E

101. Like the slide exposure series on page 88, here is a series of five 4 × 5" transparency exposures. The exposure information sheet was deleted in these examples to avoid confusion, but it should appear in each of your exposures.

102. Here are examples of commonly available 35mm slide films, equivalently exposed and processed by their manufacturers. To assure accuracy, all daylight films were exposed with electronic flash illumination and all tungsten films were exposed with new bulbs after an initial burning time of an hour. (A) Ektachrome 160, 3200K tungsten; (B) Kodachrome 25, daylight/electronic flash; (C) Ektachrome 200, daylight/electronic flash; (D) Agfachrome 64, daylight/electronic flash; (E) Kodachrome 40, 3400K tungsten; (F) Fujichrome 100, daylight/electronic flash.

Save on crystal barware and decanters

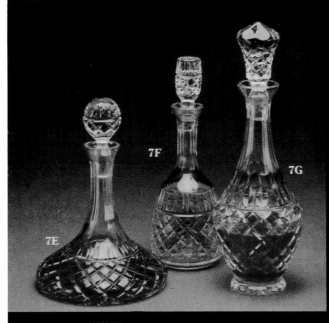

(7-A.) "LAILA" HAND-CUT STEMWARE CRAFTED IN EUROPE, IMPORTED BY CRYSTAL CLEAR
Goblet, wine, saucer champagne or cordial.
Regularly $6 each . Sale **3.99**

IMPORTED FROM FRANCE BY CRYSTAL D'ARQUE
Goblet, wine, continental champagne or cordial.
(7-B.) "ANCENIS" Regularly 5.50 each Sale **4.50** each
(7-C.) "DEAUVILLE" Regularly $9 each Sale **7.99** each
(7-D.) "GALA" FULL LEAD CRYSTAL BARWARE IMPORTED FROM ITALY BY ROYAL CRYSTAL ROCK
Choose 12 1/2-oz. hi-balls or 10 1/2-oz. double old-fashioneds.
Regularly 6 for $30 Sale 6 for **19.99**
HAND-CUT FULL LEAD CRYSTAL DECANTERS
Each decanter has its own hand ground stopper found only in the finest decanters in the world. Each stopper is individually made for its own individual decanter...this keeps the "spirits" in the bottle. By Crystal Clear.
(7-E) Captains (7-F) Cordial (7-G) All-purpose wine
Regularly $60 . Sale **39.99**
Glassware (652)

115. Light sources and their locations can often be determined by examining the specular reflections of the light sources as they appear on the surface of the object photographed. A single, large diffuse light source was used to photograph the three decanters at the upper left. The glasses and stemware below were also photographed using diffuse light. How many light sources are reflected by the glass? Where are they located in relation to the objects?

131

116. *The use of a single, diffuse light source can minimize visual confusion while clearly identifying the character of the surfaces of the objects that appear in the photograph. Here, the glass objects reflect the light source itself while the grapes and leaves forming the background for the subject appear dull and matte. The product's appearance is also enhanced by its placement in an appropriate environment. In all likelihood this environment was not a natural one but was artificially created with materials assembled in the studio specifically for the photograph. If you expect to be photographing three-dimensional objects, do you think this approach is a good one? Would you be able to assemble landscape items like these in your studio or do you think a natural landscape provides a better setting for your work?*

132

15A

15E

15B

15C

15D

15F

(15-A) FARBERWARE 12-PC. STAINLESS STEEL COOKWARE

Aluminum clad bottoms for fast, even heat distribution without hot spots.

12-pc. set includes:	Reg.	Sale
1-qt. cov. saucepan	$21	**12.99**
2-qt. cov. saucepan	$27	**16.99**
3-qt. double boiler	$53	**28.99**
4-qt. cov. saucepot	$32	**21.99**
8-qt. cov. saucepot	$43	**28.99**
10½" fry pan	$31	**14.99**

FARBERWARE OPEN STOCK SPECIALS

(15-B) 2-qt. tea kettle Reg. $34 **Sale 24.99**
(15-C) 3-pc. mixing bowl set Reg. $15 **Sale 11.99**
(15-D) Open roasting pan with rack Reg. $29 **Sale 25.99**
(15-E) 12" frypan Reg. $35 **Sale 25.99**

117. *In photographing objects with highly polished surfaces, you must be particularly careful to avoid a confusing pattern of reflections on these surfaces from surrounding objects. Since the viewer is unfamiliar with the actual appearance of the object being photographed, and particularly because the surrounding objects casting these reflections probably will not be shown in the photograph, such reflections may be misleading and may appear to be on the surface of the object itself.*

(17-A) KRUPS "BREWMASTER" DRIP COFFEEMAKER
10-cup (50 oz.) electric drip coffeemaker. Made of high-impact plastic. Dishwasher safe. Large warming plate, coffee stays hot for hours. #261.
Reg. 89.99**Sale 69.99**

(17-B) CUISINART FOOD PROCESSOR WITH EXPANDED FEED TUBE
Pulse action switch give you extra control. #DLC8E.
Regularly $175**Sale 129.99**

(17-C) RIVAL CHROME SLICER
Serrated blade cuts food wafer thin. Easy cleaning and safety guard.
Reg. 62.99**Sale 39.99**

(17-D) "BROIL KING" ROTISSERIE OVEN BROILER.
Giant oven capacity will hold a turkey or large roast even bakes cakes. Continuous clean interior, see-thru door and automatic 4-hour timer. Pilot light, thermostat control for all oven cooked foods from spit roasting to slow cooking. #560.
Reg. 139.99 .**Sale 99.99**

118. *This advertisement shows two such unexplained reflections (see Figure 117). First, several black lines are reflected in the metal frame of the broiler at the upper right, with no indication whatsoever of what caused these lines. Second, a ghostlike triangle of lighter tone is reflected on the front glass of the broiler. From experience, I know that this light tone was reflected from the table top on which the broiler was resting, but to the average viewer, the source of this reflection may not be immediately apparent.*

LONGINES

Conquest

Someone close to you is hoping for a Longines. Don't disappoint them.

Give the world's most honored watch.
Have your jeweler show you
the sophisticated new Conquest™ watches
from our Quartz International Collection.
Very Swiss. Very thin. Very Longines.

LONGINES
WITTNAUER
Time can be beautiful

119. Since there are no confusing reflections on these watch crystals, it is hard to tell if they were removed beforehand or if they were merely carefully lighted. *A diffused overhead illumination was used, but the lighting was carefully controlled to give the watches impact.*

146. Compare this color reproduction of Li-Lan's Three and Two
(C) *with the black-and-white version on page 148. Note the
subtle relationships between the basic color of the paper and the
colors of the torn pages drawn by the artist. (Photo courtesy the
artist.)*

128. *Lester Johnson*, Untitled (Head), *Oil on canvas, Collection Heckscher Museum, Huntington, New York. Anonymous gift. Basic two-dimensional lighting of this extremely dark work causes glare at the left and right sides of the painting, and in the vertical ridge of paint delineating the sitter's nose. Note that textural features are minimized throughout the work.*

129. *By using direct illumination with two lights located at a more oblique angle to the work and adding a polarizer on the lens, glare has been reduced to an acceptable level and the texture throughout has been highlighted. However, some tonal details at the lower left and right corners have been lost in the harsh contrast produced by this near-raking light.*

TEXTURE: PAPER EMBOSSMENT (FIGURES 130-131)

The principles involved in textural lighting of embossed paper are the same as those used to light textured paintings with two exceptions: (1) paper works generally lack surface reflectivity, and (2) embossed paper should always be illuminated from above.

Conventional two-dimensional lighting should never be used to light embossed paper because, while such lighting allows whatever else the work may contain to be seen, the natural "texture" or embossment of the work is lost.

Either diffused or direct overhead illumination can be used to light embossed works. The choice depends on the effect the lighting has on the character of the embossment and the overall content of the work. For example, the stark qualities of direct illumination may contradict the inherent soft, fluid qualities of the work, or the soft quality of diffused illumination may contradict the inherent harsh qualities of the work. You must exercise good lighting "judgment" to preserve the character of the embossment and the remaining qualities of the work.

130 (below). Sara Amatniek, Marathon, *intaglio. Basic two-dimensional lighting of this paper embossment and print has maintained correct rendering of the tonal elements of the work, but it has totally eliminated the character of the embossment.*

131 (bottom). Here indirect, bounce-light illumination has correctly rendered both the tonal elements and the character of the embossment. (Direct lighting, though it is not illustrated here, produced a severe, sharply delineated effect that was inconsistent with the nature of the work itself.)

MIXED MEDIA: SCULPTURAL ELEMENTS IN TWO-DIMENSIONAL WORKS (FIGURES 132-135)

Two-dimensional objects with raised, three-dimensional surfaces should be treated photographically both as two- and three-dimensional works. In other words, the entire surface of the work should receive overall, even illumination, as with any two-dimensional work, while the three-dimensional character of the surface is strengthened and enhanced by directional, textural lighting. Naturally, the textural lighting selected should be consistent both with the content and composition of the work. For example, if the subject matter of the work is lighted from above and to the right, the lighting used to highlight the textural features should come from the same direction. If it does not, the lighting effect of the textural elements may appear to be inconsistent with the lighting evident in the composition itself. The result will be a photograph with distracting information.

Textural lighting of works that are fundamentally two-dimensional must be done with sensitivity or the effect may be overpowering. Exercising care in lighting, maintaining proper levels of illumination, and controlling the direction of light adequately should prevent unsatisfactory results. Lighting effects should be critically examined and the appearance of the object in the final photograph "previsualized" before the film is actually exposed. As you gain experience it might be wise to photograph the object with several different lighting arrangements until a standard arrangement suitable to the work is achieved.

132 (left). *Chaim Tabak,* Formations—I, *oil on canvas/plaster and epoxy. This two-dimensional work contains three-dimensional elements. Although the basic two-dimensional lighting that is used here correctly renders those two-dimensional elements, it unfortunately renders the three-dimensional elements poorly. Because shadowing is minimal, the three-dimensional qualities of the work have been lost.*

133 (right). *By repositioning the lights, placing two bounce lights to the left of the work and one direct light to the right of the work, overall even illumination of the work has been maintained (as can be seen in relation to Figure 163), while the sculptural, three-dimensional features of the work have been more faithfully rendered. Note that the lighting direction and strength resembles that of the two-dimensional upper part of the work.*

134 (top). *Dorothy Lazara,* Multiples: Faces, *trapunto. Basic two-dimensional lighting of a work with high relief produces a confusing and distracting array of shadows beside each of the faces. The nose of each face is also confusingly and disturbingly shadowed as well.*

135. (above). *In this example, two bounce lights to the left of the work and one direct light to the right of the work provide even illumination and sculptural feeling without confusing shadows. The raised, relief character of the work has been preserved and faithfully rendered.*

MIRRORS (FIGURES 136-138)

Of all the problems photographers of art are likely to en-counter, photographing mirrors is among the most challenging. The principal problem in photographing mir-rors is that a mirror is not itself meant to be seen, but it is intended to reflect objects in its environment. If you remove nearby objects, the mirror simply becomes an atonal, blank space within a larger work. If you add ob-jects so that the presence of the mirror can be discerned, and you run the risk that they will detract from the ap-pearance of the object or distract the attention of the viewer from the work itself.

Aside from aesthetic considerations, photographing mirrors also presents a physical problem. The camera and the photographer must be located in front of the work so that it can be photographed, but they must not appear *in* the photograph. To solve this, you can usually move to one side of the mirror so that a blank surface of smooth paper or a painted wall is reflected in the mirror.

The advantage of viewing the mirror from one side is that the edge of the mirror's frame is reflected in the mirror, delineating its presence without detracting from its appearance. However, if you are using a rigid body camera, such as a 35mm SLR, it will then produce a dis-torted image of the work, with the near side of the mirror frame appearing longer and the far side shorter than they actually are relative to one another.

If you are using a view camera, on the other hand, you can avoid this particular problem. While you place the camera to one side of the work, keep the lens panel and ground glass parallel with the work itself. Distortion of the work is thus eliminated while the visually attractive side view is maintained.

136 (above left). *Peter Resnick,* Mirror, *Curly yellow birch and mirror. Photographed as a standard two-dimensional object, a mirror naturally reflects the camera that is photographing it.*

137 (above). *When the mirror is viewed from the side, it is a good idea to have the edge of the mirror's frame reflected in it to clarify the fact that we are viewing a mirror without detracting from its appearance. But when rigid-body cameras shoot at an angle, they produce a distorted image of the work, with the near side of the mirror frame appearing longer and the far side shorter than they actually are relative to another.*

138 (left). *Using a view camera corrects the problem of distortion and still maintains the attractive side view position. While the camera is placed to one side of the work, the lens panel and ground glass are kept parallel with the work itself. Distortion of the work is thus eliminated, while the attractive side view is maintained.*

LARGE TWO-DIMENSIONAL WORKS
(FIGURES 139-140)

It is difficult, though not impossible, to photograph large two-dimensional works in relatively small spaces because of restrictions in the placement of the camera, the object, and lighting equipment. For example, in a small studio area, lights may be placed too close to a large work for it to receive overall even illumination. Also, areas near the edge of the work which are closest to the light source(s) will appear lighter than areas close to the center of the work that are farthest from the light source(s).

The effect of uneven illumination is most noticeable in works that have areas of tonal equivalence throughout. When such areas receive different levels of illumination, they appear to contain different tones, although, to the untrained eye, such tonal differences may not be perceived. Therefore, to insure that equal levels of illumination are achieved under all lighting conditions, a reflectance meter and gray card or an incidence meter should be used at all times. It may become apparent that wherever the lights are located, the illumination levels across the surface of the work remain uneven. Thus, if it is absolutely necessary to photograph large works in a restricted area, use indirect bounce lighting because it can be spread more evenly across the surface of the work than direct lighting. When indirect lighting is used, however, you may require more light sources to maintain an adequate level of illumination. The minimum number of lights used for bounce light illumination should be four; two aimed toward the ceiling of the room and two aimed toward nearby walls. If light from above is the only light falling on the work, the upper part of the work will receive significantly more illumination than the lower part of the work. Obviously, all wall and ceiling surfaces must be white, since any other color would be reflected onto the work and would affect the color rendition of the final film image.

Also, check carefully to see that no light reflected by objects in front of the work inadvertently strikes the work. Such reflected light would cause a lightening of tone and loss of faithfulness in the rendition of the work.

If you find, even with bounce lighting, that the work cannot be properly illuminated in the space available, try to move the work outdoors. By setting up a studio outdoors at night, you will benefit both from the increased (almost limitless?) size of the "studio" and the surrounding blackness of the night. This arrangement may not work for everyone, but it can provide a studio-like space for those who otherwise would have no studio at all.

139. *Fanny Sanin*, Acrylic No. 1, 1976, *acrylic on canvas. Lights placed too close to large works in confined or restricted work areas, will prevent overall even illumination from being achieved. Here the left and right sides of this 54 × 74" (137 × 188 cm) canvas have received too much light relative to the remainder of the work.*

140. *Bounce lighting using four lights permitted this work to be evenly illuminated in spite of a restricted work area. The entire process of lighting this particular work, and others in a group of similar size works, took about forty-five minutes, with numerous checks on the level of illumination present over the entire surface of the work.*

LOW-CONTRAST SUBJECT: BLACK-AND-WHITE PENCIL DRAWING (FIGURES 141-143)

Pencil drawings are usually low-contrast subjects. That is, when the drawing consists primarily of pencil lines against a background of white paper, the range of dark to light tones is limited and difficult to measure. As a consequence, when the image is recorded on black-and-white negative film and then printed, the paper is no longer white but is a light gray, and the pencil lines are very faint. If the image is "enhanced" so that these lines are darkened, then the paper becomes an even darker gray. In all, the photographic image does not accurately represent the object.

The problem is increased when the photographic image is reproduced mechanically, as in books or magazines. This type of reproduction reduces black tones, white tones, and intermediate shades of gray into a range of gray tones. Black becomes dark gray and white becomes light gray. As a result, the range of contrast in the photograph is reduced, and the white/light gray background which represented the white paper upon which the pencil lines were drawn becomes a light-to-medium gray tone and the pencil lines lose significance.

One commonly used method of controlling the contrast in a black-and-white negative is to underexpose the film and extend the development time (or overdevelop). This increases image contrast in prints made from the negative as well as increasing contrast in the negative itself. However, the exact amount of underexposure and over-development necessary to achieve a print that satisfactorily represents the work must be determined experimentally. If you cannot afford the time or lack the enthusiasm for such experimentation, consult the technical representatives of a nearby professional processing laboratory. They are interested in your business and will thus provide the information you need. By following their advice, you also will provide them with negatives best suited to their printing methods.

If this method is unsuitable for your requirements, you might wish to photograph the work in color and have color prints made from negatives or transparencies. While this is more expensive than black-and-white printing, the images may be more accurate tonal renditions of the work in terms of contrast. Remember that prints made from slides will exhibit an increase in contrast over the slide, which itself exhibits an increase in contrast over the work.

141 (opposite page, top). *Sylvia Pauloo-Taylor,* L Wall
Series No. 3, *1977, pencil on paper. It may be obvious here
that mechanical reproduction of pencil drawings and other
works on paper does not generally do justice to the original
works or to the photographs used in the reproduction proc-
ess. Nonetheless, the photograph of the work reproduced
here represents a normal print of a normal negative of a
pencil drawing on white paper. As you can see, the print
lacks contrast and tonal separation. The individual, light
pencil lines are difficult to distinguish from the gray of the
background.*

142 (opposite page, bottom). *This "enhanced" normal con-
trast print was simply printed to obtain a darker print
image. But it also produces a darker paper image, while
not improving the contrast. The entire print now appears
"muddy."*

143 (above). *By underexposing and overdeveloping the
negative, print contrast has been increased. The exact rela-
tionship between underexposure and overdevelopment,
however, should be determined experimentally.*

LOW-CONTRAST SUBJECT: COLORED DRAWING (FIGURES 144-146)

Low-contrast subjects containing color can best be photographed in black-and-white by using appropriate lens filters to increase the contrast of the subject so that, when printed, the final photographic image more closely approximates the image as perceived visually. Consult the filters section of Chapter 4 and select a filter that will best enhance image contrast based on the color or colors of the subject.

If several colors are evident in the work, it may be best to photograph the work in color. Prints can then be made from the color negative or slide.

144. Li-Lan, Three and Two (C), *1980, 22½ × 30″ (57 × 76 cm). (Photo courtesy the artist.) A normal black-and-white rendition of this pencil and watercolor drawing produces an acceptable, but relatively low-contrast image of the drawing, which contains subtle differences of color. No filters were used to expose the film.*

145. A red filter was used to expose the film for this photograph, resulting in a darkening of the blue portions of the image. This restored the gray tonal value of the blue area of the work to the tone contained visually in the original drawing. (Compare this black-and-white reproduction with the actual colors of the work on page 136 of the color section).

WORKS UNDER GLASS (FIGURES 147-149)

There is a popular misconception that photographing works under glass is difficult. Quite the contrary is true. Photographing works under glass has distinct advantages both for the artist and for the photographer.

First, the work is amply protected when framed under glass against potential damage from improper handling while being photographed. Second, a work under glass is usually matted or otherwise framed in precisely the way the artist wishes it to be seen. No ragged paper edges, marks on paper margins, or other matter is seen or recorded on the film. Third, the work is held flat beneath the mat and covering glass, assuring proper orientation in the viewfinder and on the film once the work is properly aligned in the viewfinder. Fourth, the work can be hung, stood on a table, or placed on an easel when matted and framed. As a consequence, no accessory materials are required to hold the work in place while it is being photographed.

The only disadvantage to photographing works under glass is the reflective nature of the covering glass itself. But this is easily controlled.

Light is reflected by the covering glass because light

147. Lisle Spilman, sketch for Wave Captured in Blue, *acrylic on paper. Light striking objects in front of a work under glass is reflected toward the glass and by the glass back toward the camera. Reflections such as this are most commonly noticed with darker works under glass as many reflections are lost in the white paper background of lighter works. They are, of course, precisely the same reflections under identical lighting conditions. They simply are not noticed.*

strikes the glass. When lights are properly positioned for basic two-dimensional lighting, the light produced may also strike objects in front of the work. The light reflected by the objects is then reflected by the covering glass toward the camera.

Interposing a black cloth, which absorbs light, between the camera (and other reflective surfaces/objects) and the work prevents light produced by the light source from striking them and being reflected in the glass. In some cases, the cloth need only be large enough to cover the camera and photographer while the object is being viewed and photographed. In other cases, several cloths may be required to completely hide a large area immediately in front of the work which otherwise is reflected in the covering glass.

If a single cloth is used, it can be hung from the ceiling or simply draped over the camera and photographer. A small slit is cut in the cloth through which the camera lens protrudes for photographing the work. If two or more cloths are required, they can be hung from the ceiling

148. Black cloths are positioned between the camera and the object under glass to absorb light emitted by the light source(s) before it strikes objects in front of the work. This, therefore, also prevents light from being reflected by the covering glass of the work.

using thumbtacks, pushpins, or staples. They should overlap slightly where they join so the camera lens can protrude between the cloths without allowing the photographer or tripod to be seen.

Equivalent reflections are more visible against a background of black paper than a background of white paper beneath a covering glass. Hence, dark works are much more likely to evidence problems under glass than light or white works. With works of either type, however, care should be exercised that all possible sources of reflection in front of the object are controlled. Even the smallest source of reflected light can cause the entire effort to control reflections to be wasted.

Do *not* purchase a polarizer with the hope that it will control reflections in the glass and obviate the need for black cloths. The polarizer will have *absolutely no effect* in controlling reflections when the camera is placed directly in front of the work under glass being photographed.

149. With the black cloths in place, the work is rephotographed without any indication whatsoever that is has actually been photographed under glass.

DISTORTION (FIGURES 150-151)

Distortion of three-dimensional objects in photographic images occurs whenever the plane of the object being photographed and the plane of the film in the camera are not parallel. During the testing procedure, distortion apparent in the viewfinder indicated that the plane of the object, the *two*-dimensional test panel, and the film plane were not parallel. However, when photographing *three*-dimensional objects, such distortion, which causes convergence of parallel lines in the image, may not be immediately apparent simply because the form or shape of the object does not contain true horizontal or vertical lines.

When this is the case, the simplest way to check that the plane of the object and the plane of the film are parallel is to visually compare the plane of the film at the back of the camera with a true vertical line. For instance, compare the position of the back of the camera with a vertical wall line, doorway edge, or window. If they are in approximately the same vertical position, there should be little distortion. If they are not, there probably will be distortion.

If a 35mm camera with a fixed camera body is being used and is pointed downward toward a vertical object, the top of the object will appear larger and the bottom smaller than they actually are relative to one another. This occurs simply because the top of the work is closer to the camera than the bottom of the work.

To correct the apparent distortion of the object in the viewfinder and in the film image, you must adjust the 35mm camera body to a vertical position (the same position as the object) and lower the camera to a height equal to the distance from the floor or ground to the center of the work (so the object remains centered in the viewfinder and in the film image.). But as a result, the image in the viewfinder no longer reveals the sculptural character of the work.

You will have this problem with all cameras except those that allow the use of expensive, wide-angle perspective control lenses and those that do not have a fixed body, such as the view camera with its flexible bellows. The view camera, by virtue of its design, allows the photographer to photograph the work from above while maintaining a parallel relationship between the film plane, the lens, and the plane of the object. As a result, the image viewed and recorded faithfully renders the object as vertical and sculptural.

150 (above). *Sanda Vero,* Bust, *mixed media on wood. When a fixed-body camera is used to photograph any object from a position where the film plane is not parallel with the plane of the work, distortion results. Here, in addition to distortion, this 13 × 9 × 9½" (33 × 23 × 24 cm) work has also been photographed under a high-contrast-ratio lighting, with the result that the image on the left side of the work has been obscured in the high level of illumination.*

151 (left). *In this rendition of the object, sculptural lighting is less contrasty. This change in lighting plus the use of a view camera have produced a faithful rendition of this work with no distortion and true sculptural perspective.*

SCALE (FIGURES 152-156)

A photographer of an object presents some information about the object itself; its range of tones, coloration, shape, surface character, and texture. It cannot convey substance, weight, or size. An object may be strong and yet appear fragile, it may be heavy and look weightless, or it may be very small and appear quite large.

Unless the object is reproduced photographically in the same size or scale as the object itself, and the photograph is labeled accordingly, the appearance of the work in a photograph will be inexact and deceptively large or small.

To remedy the problem, you can include an object of known size with the work of art in at least one photograph. Museums recording an object photographically for archival purposes often include a ruler with the object or specimen which shows the size of the object precisely. While this is informative, it is unattractive.

For archival purposes, such photographs need not be attractive, but for purposes of illustration, presentation, or publication, photographs must present an object in an accurate but also attractive manner. The two cases cited here, small pottery and a maquette (scale model) for an environmental sculpture, address different problems of scale. Therefore, in approaching problems of scale, the ultimate use of the photographic image should always be clearly determined beforehand. Ask yourself the following:

1. Will the photograph simply be a record of the work to be used by the owner or artist?

2. Will the photograph be reproduced in a brochure, postcard, gallery announcement or newspaper where relative size or scale may have little importance?

3. Can the size of the work be indicated on the back of the photograph or printed, if the work will be reproduced, in close proximity to the reproduction?

152 (top left). A bowl and pitcher was selected from a large group of miniature porcelain objects.

153 (middle left). Gilda Weinstein, Small Bowl and Pitcher, Salt-glazed porcelain. This small bowl and pitcher, approximately 1½" (38 mm) high, is first shown without reference to any object that might indicate its relative size or scale. As a result, it is difficult to interpret. Is it a large photograph of a small object, or a photograph of a normal subject?

154 (left). Here the bowl and pitcher are shown in relation to an object of known size, a dime. Clearly this detracts from the image of the object itself, and would not be used as a photograph for reproduction purposes, but it might be used to accompany other object photographs for personal records. Or it might accompany other photographs sent with press or publicity packets. For printed reproductions of the work, information indicating the size of the work could easily be printed nearby, thus indicating the relative size of the work in a nonphotographic manner.

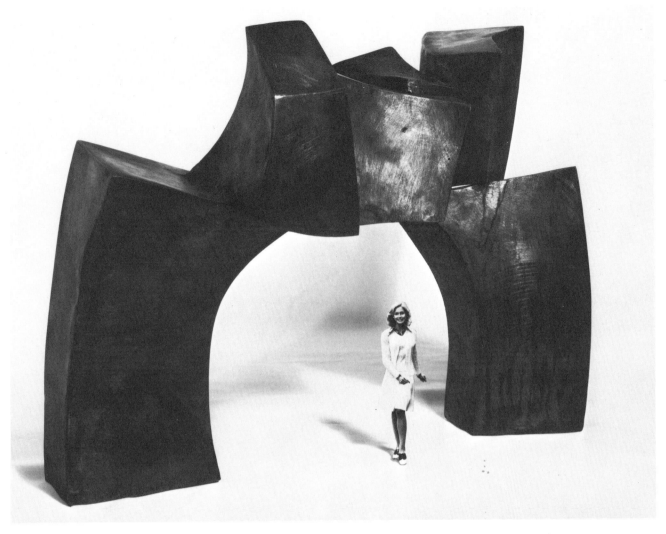

155. *Charles Reina,* Maquette for Environmental Sculpture, *bronze. This work has also been photographed to convey its size in relation to an "object" of known size, in this case a person. To accurately portray the scale of this work as a finished sculpture, a figure was selected from a catalog and photographed (Figure 156). A print from this negative was then made to match the scale of the maquette. A paper clip attached to the back of the cut-out figure was attached to the background material beneath the sculpture.*

A single light source illuminated the work, as it would be lighted outdoors as a finished piece, so that the shadows created by the light and the object would appear natural. Indirect lighting might also have been used.

When all the elements were in place and the lighting properly arranged, the photograph was taken. Although the sculpture was simply a model, it has been reproduced as if it was a full-scale object. The resulting photograph allows the artist to present the work to potential clients so they can visualize the work as it will appear when completed.

156. *This is the photograph selected from the catalog to be used to show the relative size of the sculpture.*

157. Julian Wolff, Vases, *blown glass with inclusions. Standard sculptural lighting of glass results in specular reflections or "hot spots," one of which has obscured a delicate area of patterning in the glass near the neck of the bottle.*

158. Backlighting can be used successfully with some glass objects, as shown in this instance. However, shadows created with backlighting may interfere with the visual impact of the work itself.

GLASS (FIGURES 157-160)

Glass is a most interesting substance. In some forms, it is nearly or totally opaque, while in other forms, it is translucent or transparent. Furthermore, the range of objects encompassed by the word "glass" is enormous.

Glass presents particular photographic problems in that it both reflects and transmits light. And since glass combines both surface and substance, it depends less on surface characteristics alone than do other objects. In the more transparent glass object, you see not only what is on the surface, but what is contained within its structure—within the object itself.

Standard three-dimensional lighting of glass produces specular reflection or "hot spots" that are distracting and virtually hide information contained in the work. Such reflection cannot be controlled adequately by using a polarizer on the lens, with or without sheets of polarizing material over light sources.

A standard means of lighting glass is the light table, which provides indirect back lighting of the work and allows it to be photographed without specular reflections. Obviously, this lighting technique is useful only with transparent or translucent glass objects. Opaque glass objects should be treated photographically as highly polished objects.

If money is no object, a light table can be purchased from a number of sources providing ready-built models with various features. But if you wish to make your own, an inexpensive, easily set up and removed light table can be constructed with the following materials: two sawhorses or other supports, a sheet of glass to support the works photographed, and a large sheet of diffusion material. Studio lights are directed upward through the glass and diffusion material and illuminate objects placed on the glass from beneath and behind.

The fundamental problem in using this method is that the standard method of metering exposures cannot be used because there is no light reflected by the object and, therefore, there can be no measurement of light in accordance with previously established practice. You must experiment to determine the proper exposure to use.

As a starting point, consider the illuminated diffusion material as a white reflective board reflecting five times the amount of light normally reflected by a gray card. Measure the illumination of the diffusion material and multiply the shutter speed indicated at any particular aperture by five, so that an exposure reading of f/11 at 1/125 second becomes f/11 at 5/125 or 1/25 second. Round this number off to the shutter speed closest to the speeds indicated on the camera and take a series of exposures at that aperture and two stops above and below that aperture in ½ stop increments. Keep a notebook record of the entire procedure and when slides are returned (and the test should only be performed with slide film), transfer the information to the slide mounts for reference.

Select the slide that best represents the work and use this as your standard. Continue to bracket ± one stop until the initial results are confirmed. Once this standard is established in relation to the metered exposure values, the difference should be factored into each subsequent exposure calculation, just as was done during the testing procedure.

159. A light table consisting of two sawhorses, a sheet of glass capable of supporting the works to be photographed, a large sheet of diffusion material, and one or two photo lights are all that is required to construct a simple light table.

160. The results obtained by using a homemade light table are almost indistinguishable from those obtained with more expensive versions. One helpful note: the dark vertical lines along the outside of the work are caused by the dark lines produced in the diffusion-material by the sawhorses. To minimize such lines, use a table surface as wide as possible.

BACKGROUNDS (FIGURES 161-163)

Selecting an appropriate or unappropriate background for an object can have a profound effect on its photographic representation. Two-dimensional works should always be photographed against a neutral gray, white, or black background so that the background in no way competes with the work for the attention of the viewer of the photograph. A black background should be "standard," as it isolates the work completely. In slides, the object alone is seen when the image is projected and slide "masking" or taping, which can be a time-consuming task, is virtually eliminated.

Three-dimensional works can be photographed against a neutral background or one in a color that complements the colors of the work itself. But in no case should the background color overpower the colors of the work. Deep shades or pastel tints are best, since middle tones will tend to distract the viewer's attention.

161. Ibram Lassaw, Space Loom XXIII, *Bronze, Collection of the Heckscher Museum, Huntington, New York. Museum purchase. Placed on a white background and illuminated with a single light from above and to the right,* Space Loom XXIII *stands out as a darker object than in Figures 162 and 163.*

162. When the work is displayed against a medium-gray background and lighted with an additional fill light from above and to the left, a confusing array of shadows appear. In Figure 161, the white paper added reflected fill illumination to the "legs" of the work, but here the gray paper background creates less reflected light. As a result, the legs appear darker. To avoid a confusing array of shadows, especially with light-toned backgrounds, use indirect illumination. This work would be shown to best advantage indirectly illuminated and displayed against a medium-gray background.

163. Shadows disappear against a black background, but so does the fill light provided by the white and gray background materials used in Figures 161 and 162. As a result, the "legs" are extremely dark, blending with the background to a large extent.

FILL LIGHTING (FIGURES 164-169)

When an object is illuminated with a single light source, deep shadows may be created where information contained on the surface of the work is lost. Consequently, you may need to use additional light to "fill" the shadowed area with light and reveal details that were previously hidden.

Reflectors or secondary "fill" lights, less powerful than or located a greater distance from the object than the main light, can be used with great effectiveness to reduce the harsh shadows created by a single light and also to reduce the overall contrast of the image. When aimed directly at the work, secondary lights may cause unusual or distracting shadow patterns, or highlights, to appear. Reflectors, on the other hand, provide broad, even, and shadowless illumination with a great deal less investment in equipment.

164 (right). *Richard Shanley,* Hollow Container, Zebrawood. *A single light is used to illuminate the work, and as a consequence, especially against a dark background, a deep shadow is evident along the right side of the work toward the rear.*

165 (opposite page, left). *A white reflective panel is placed to the right of the object to provide fill illumination. The very base of the work still could receive more illumination, but the dark cloth beneath the work absorbs all potential reflected light.*

166 (opposite page, right). *Against a white background, the ornamental nearly white dried flowers virtually disappear, but the white background paper provides even reflective fill illumination. What other background materials might have been used with this combination of dark and light tones in a single subject?*

167 (above). *Lillian Dodson, Vase, glazed ceramic. Dark shadowing created by a single main light located to the left and above the work creates a distorted image of the object. Note the "hot spot" created by the main light, and the excellent modeling of the glaze at the bottom of the work.*

168 (above right). *A reflector is placed beside the work, but because of the highly reflective glaze on the work, both the light reflected by the reflector and the reflector itself can be seen as part of the work.*

169 (right). *In an attempt to control this reflection while allowing the reflector to provide fill lighting, a polarizer is attached to the lens and oriented to remove as much of the reflected image of the reflector as possible. While not totally successful, much of the reflector's image disappears, though it continues to provide fill illumination.*

GLARE (FIGURES 170-175)

When lights are placed at an angle to the surface of the object, they cause the surface to reflect that light directly toward the camera or viewer. The result is glare. When glare exists, areas of the surface from which the light is reflected appear whitish or "washed out" because what is being seen is the reflected light rather than the surface coloration of the work.

The most effective way to eliminate glare is to reposition lights (indoors) or relocate the object in relation to the direction of the light (outdoors). Indoors, you can move the lights closer to the plane of the object or to the wall on which the work is mounted so that the angle of the light striking the work is more oblique. But do not, however, move the lights closer to the work itself. Outdoors, reposition the work so that the light strikes the surface of the work at an oblique angle. If the work cannot be moved sufficiently, you may have to wait until the sun is correctly positioned in the sky to create an oblique angle of light.

170. Sylvia Pauloo-Taylor, Double Wall II, *acrylic on canvas. Glare can also be caused when objects in front of the work reflect light directly onto the object. That reflected light is then, in turn, reflected by the work directly toward the camera. Here, glare produced by a reflective object in front of the camera is visible at the bottom center of the work. Ceilings, walls, and floors can also be sources of such reflected light.*

171. Black cloths hung between the work and the camera, such as those in Figure 148, control and eliminate this source of glare so the work can be seen without visual interference from such spurious reflections.

172 (above). *Janet Schneider,* Smithsonian, *oil on canvas. Basic two-dimensional lighting consists of lights positioned so that: (1) the object illuminated is evenly illuminated across its entire surface, and (2) direct light produced by the light source(s) is not reflected by the work toward the camera lens. Improperly positioned light sources may meet the first condition but not the second and, as a result, glare is produced.*

Here, two studio lights have been properly positioned for even illumination of the work, but they have been placed too near the camera—that is, more directly in front of the work than is desirable. Consequently, the light is reflected by the work near its edges, and the glare is apparent.

173 (right). *This detail shows the effects of glare on the appearance of the work.*

174 (above). With studio lights correctly repositioned closer to the plane of the object, glare is reduced to a minimum and the true colors and tones of the subject are visible.

175 (left). You can see in this detail, glare has been effectively eliminated by correct repositioning of the lights.

REFLECTIONS (FIGURES 176-187)

All objects reflect a portion of the light that strikes them. The *amount* of light reflected by the object affects the tonal (dark or light) appearance of the object. In other words, those that reflect very little light appear dark, while those which reflect a great deal of light appear light.

The *surface* of the object and its *character* (such as its shape, smoothness, sheen, or polish) determine the *appearance* of the light reflected by the object. Problems of reflection are generally caused by the object and are not readily controlled or corrected. What controls are available are limited to arranging the lighting or preventing the object from being misrepresented photographically in spite of reflections which may occur.

Some photographers apply a matte, dulling spray to highly polished surfaces that can be removed when photographic work is completed. Dulling the surface permits designs and other information otherwise obscured by specular reflection to be seen and recorded. The spray should only be used when absolutely necessary, however, and its use is not recommended here because the application and chemical removal of the spray may actually damage the object.

Unfortunately, there are no "easy" solutions to the problems associated with highly reflective objects. The examples cited here represent some, but by far not all, of the problems likely to be encountered.

176. Helen Baskin, Black Burnished Vessels, *clay. Helen Baskin's works present two basic problems. First, the surfaces of the works contain various combinations of highly polished, matte (dull sheen), and textured features, all of which must be accurately rendered. Second, as black objects, they must be presented so that the surfaces* look *black. Black polished surfaces of three-dimensional works under glass reflect light. Light-colored objects or surfaces reflected from polished black surfaces cause those surfaces to appear to be lighter than black, inaccurately portraying the work.*

Placed on a light-colored support, which is reflected in the bottom third of this particular work, a typical vessel photographed outdoors illustrates these problems.

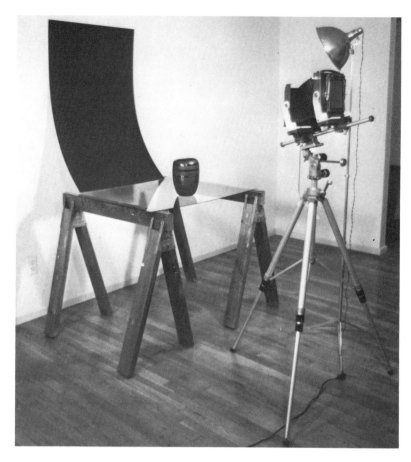

177. *To photograph the object in a more suitable fashion, a simple table support was assembled using a piece of glass of suitable strength and two sawhorses. As seen here, the work is placed on the glass and lighted with a single light above and to the right of the camera. Note that the white wall behind the table could be reflected in the glass, as is the vessel. Since this would detract from the image, to prevent it, a piece of black illustration board rests against the wall at the rear of the table. The board not only prevents the wall from being reflected in the glass, but it also prevents the image of the vessel (which is always reflected in the glass) from being seen. The camera is positioned so that it looks down through the glass to the white wall beneath the table which serves as the background for the work without actually being in proximity to or actually touching the work.*

178. *The resulting photograph shows the work isolated against a light gray background (the white wall). No reflections of either the work or the white wall interfere with the appearance of the work. To hold reflections of light sources to a minimum so that the surface texture and polished/matte character would be clearly seen, a single, direct light source was required. Indirect illumination and/or the use of reflectors, even for minimal fill lighting, would cause the difference in reflectivity between the matte, dull surfaces and the polished surfaces to be minimized. It is also likely that the use of reflectors or other indirect light sources would cause precisely the kind of light reflections in the work that would lighten the black color of the work and result in an inaccurate tonal appearance.*

179. *Marek Cecula,* Graphic Vase, *ceramic. White glazed ceramic objects generally require direct lighting to accurately portray the glassy character of their surfaces. Specular reflections ("hot spots") caused by direct lighting are minimally distracting because they are seen against the white tone of the work. They should occur, however, in areas that do not contain design or other information that they might obscure. Here the work is illuminated using one main light left of and above the work and one fill light right of and above the work. The fill light is farther from the work than the main light. A black background was selected to: (1) isolate the work; and (2) prevent shadows created by the direct lighting with two lights from interfering with the appearance of the work.*

180. *In this example, a combination of direct and indirect lighting results in a less successful rendition of the work. The main light* (left) *was aimed toward the ceiling to create indirect, bounced lighting. The fill light* (right) *was aimed so that a* small *amount of direct light fell on the work, in order to create a small specular reflection. As a result, the lower half of the work received insufficient illumination, the visibility of the horizontal seam where the top and bottom halves of the work were joined is unnecessarily increased, and the opening at the top of the vase is much less clearly defined and shadowed.*

181. *Charles Reina,* Torso, *polished bronze. Polished metal sculpture presents a difficult array of photographic problems. First of all, like a mirror, the sculpture exists both as the object itself and as a reflector of the surrounding environment. Therefore, the placement of your photographic equipment is critical. Then, not only must the work appear undistorted in the photograph, but you must be sure your equipment is not reflected in the object. Finally, you must reveal the object's texture, even if it is smooth and highly polished (and therefore reflective).*

The work shown here was placed at the end of a long table. Lights were placed near the work, above and to the left and right of it. The camera was located at the opposite end of the table, just above table height. It was not covered with a black cloth. As a result, the supporting table, light stands, camera, and photographer's hand are all reflected on the sculpture. The table is the gray form in the lower half of the object and the light stands are the two white vertical lines at the upper left and right sides of the work. While the sculpture's reflective nature has been preserved and the work is not distorted in the photograph, the picture clearly could have been improved had the camera been covered by a black cloth and had a contrasting background been used.

182. *The camera and photographer's hand can clearly be seen at the center of the work in this enlargement.*

183 (above). *Highly reflective metal and glass objects (such as those in Figures 116 and 119) are usually photographed by reflecting light indirectly onto the work from large white panels. This was impractical here because the cloths would have to cover too large an area and would thus cause the surface to appear light or white. So instead, the work was placed on a narrow board supported by two sawhorses. Small pieces of white paper were placed to the left, right, and front of the base, and larger pieces put in the background so they weren't reflected. Note that the base of the work only reflects the surface it rests on, not the white paper background.*

184 (above right). *The view camera was positioned in front and to the left of the work so the image was not distorted. The floor, camera, and wall were covered with black/gray material so they did not reflect in the work. The work was lighted directly by a single light above and to the right to highlight the polish marks on its surface. A second light source lit the background paper and wall for a fairly even tone.*

186. *Paul Johnson,* Gulliver Tied, *mixed media. Works housed within plastic enclosures (cylinders/boxes) present two problems of reflection. First, the box surfaces reflect the camera/tripod and any other objects outside the work. And second, the box reflects the objects within the enclosure on its inside surfaces. Here, the work is distorted (top larger than bottom), the tripod is reflected in the front and rear plastic surfaces as a gray line, and the subject is reflected at the left, right, and back of the interior of the box.*

187. *By using the view camera and adjusting the lens and ground glass panels to a vertical position while pointing the camera downward toward the object, the vertical lines of the work have been correctly rendered. Also, a black cloth covering the camera and tripod has prevented the tripod from reflecting light onto the work and, therefore, its reflection has been removed. Internal reflections, however, remain.*

188. *In this case, the plastic box could be removed, so the distracting internal reflections could be eliminated. But had the box been an integral part of the work and therefore unremovable, there would have been no way to control these reflections. But if you were able to lift the lid momentarily, even though the box would have to appear in the photograph, you could eliminate the reflections by attaching pieces of paper the same color as the paper beneath and behind the object. You would then use indirect or diffused lighting and choose a background color other than black to prevent the shadows cast by the work from falling on the paper in the box and confusing the final image.*

APPENDIX

CUSTOM LABORATORIES

Custom laboratories are designed to meet the needs of both amateur and professional photographers. Most publish catalogs describing the services they offer, the length of time required to perform the services, and the prices for each service or item ordered. In general, prices are moderately to substantially higher than those charged by neighborhood photofinishers offering competitive services. A custom laboratory, however, performs specialized services and provides technical assistance not otherwise available to the photographer.

If you require the services of a custom laboratory on a regular basis, it is recommended that you develop a working relationship with a laboratory that best understands your requirements. The laboratory personnel should be able to help in all areas of film exposure, film types and their uses, and image quality (both film and print).

Custom laboratories are located in major cities throughout the United States and Canada. To find one that suits your needs, ask professional, commercial photographers listed in the local telephone directory to recommend laboratories with which they are familiar. Also, write to the laboratories for catalogs and phone them, if necessary, for instructions on shipping exposed film. They may provide order forms, shipping containers or envelopes, and other materials as part of their service.

The following custom laboratories are recommended by the author. The author does not, however, assume and hereby disclaims any liability to any party for any loss or damage resulting from the use of these services including, but not limited to, loss or damage of film or prints, by negligence, accident, or other cause.

Berkey K+L Custom Service, Inc.
222 East 44th Street
New York, N.Y. 10017
Telephone: (212) 661-5600

Meisel Photochrome Corporation
Box 6067
Dallas, Texas 75281
Telephone: (214) 637-0170

Modernage Photo Services
319 East 44th Street
New York, N.Y. 10017
Telephone: (212) 532-4050

Stewart Color Labs.
563 11th Avenue
New York, N.Y. 10036
Telephone: (212) 868-1440

Titus Fine Art Photo
P.O. Box 2959
Huntington Station, N.Y. 11746

MANUFACTURERS/SUPPLIERS
The companies listed below manufacture materials useful
in the lighting and/or display of objects. Prices are listed
only for general information as to cost and are effective
as of the date of publication. Write these companies for
latest catalogs and pricing.

The BD Company
P.O. Box 3057
2011 West 12th Street
Erie, PA 16512
Seamless background paper rolls in colors
 52″×36 feet (132cm×11m)=$14.95
 107″×36 feet (344cm×11m)=$24.95
Light tent; translucent; cone-shaped
 24″ (61cm) high, 27″ (68.5cm) diameter at base = $12.95
Trans-Lum diffusion material (used over glass to make
an inexpensive light table)
 54″×18 feet (137cm×5m)=$16.95

Studio Specialties, Ltd.
409 West Huron Street
Chicago, IL 60610
Sweeptable (light table) features table frame with acrylic
table top which is opalescent, smooth on one side and
sand blasted (matte) on the other, $450.00.

Accessories Unlimited
16631 Bellflower Blvd.
Bellflower, CA 90706
Prolight Adapter converts conventional incandescent
lamp socket to tungsten-halogen lamp socket, allowing
use of long-life tungsten-halogen bulbs in such reflectors:
 250-watt quartz adapter with quartz light, $39.95
 500-watt quartz adapter with quartz light, $42.95.
Other equipment available includes various types of re-
flectors, lighting systems, light stands, and a light table
system:
 3 foot × 4 foot (91×122cm) light table, $249.95
 3 foot × 4 foot (91×122cm) cover canopy (for tent light-
ing), $99.95.

BIBLIOGRAPHY

GENERAL WORKS

Birnbaum, Hubert C. *Amphoto Guide to Cameras*. New York: Amphoto, 1978.

Cole, Stanley. *Amphoto Guide to Basic Photography*. New York: Amphoto, 1978.

Davis, Phil. *Photography*. Dubuque, Iowa: William C. Brown, 1972.

Hedgecoe, John. *The Photographer's Handbook*. New York: Alfred A. Knopf, 1977.

Sussman, Aaron. *The Amateur Photographer's Handbook*. New York: Thomas Y. Crowell, 1973.

Swedlund, Charles. *Photography*. New York: Holt, Rinehart and Winston, 1974.

ENCYCLOPEDIC WORKS

Carroll, John S. *Photographic Lab Handbook*. New York: Amphoto, 1979.

Eastman Kodak Company. *Encyclopedia of Practical Photography*. New York: Amphoto, 1977.

The Focal Encyclopedia of Photography: Desk Edition. New York: McGraw-Hill, 1969.

DARKROOM AND PROCESSING

Brooks, David. *How To Select and Use Photographic Materials and Processes*. Tucson: H. P. Books, 1979.

Curtin, Dennis, and De Maio, Joe. *The Darkroom Handbook*. New York: Curtin & London and Van Nostrand Reinhold, 1979.

Grill, Tom, and Scanlon, Mark. *The Essential Darkroom Book*. New York: Amphoto, 1981.

INDEX

Set in 11-point Century Schoolbook